KORI NEWKIRK 1997-2007

D0814460

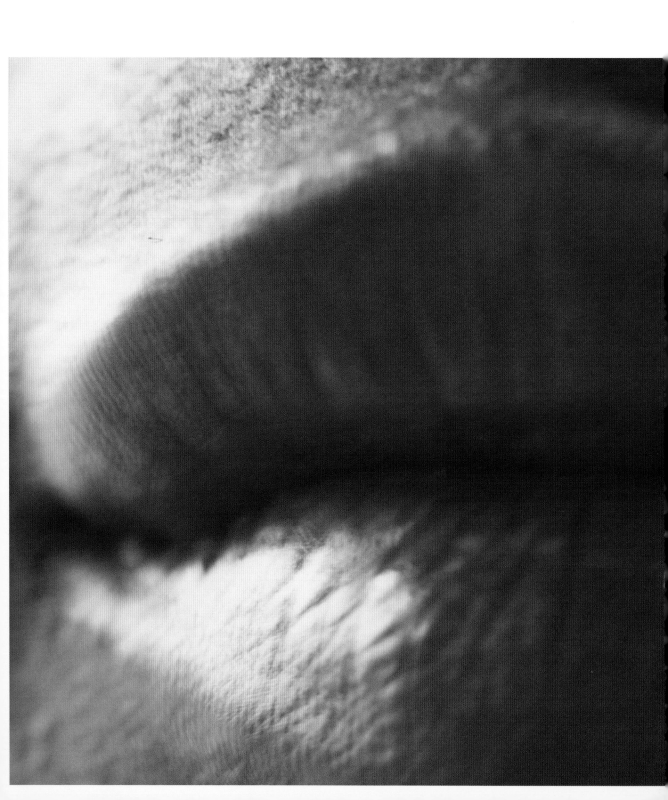

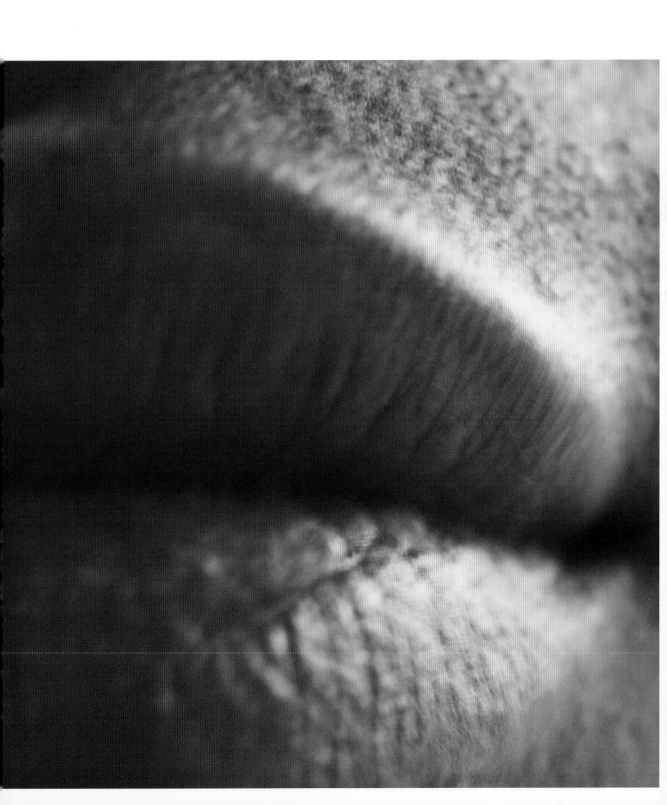

CATALOGUE CONTEN

S

D

CE

ACT! 1997-2007

AND ESTRANGED

CONTINUED

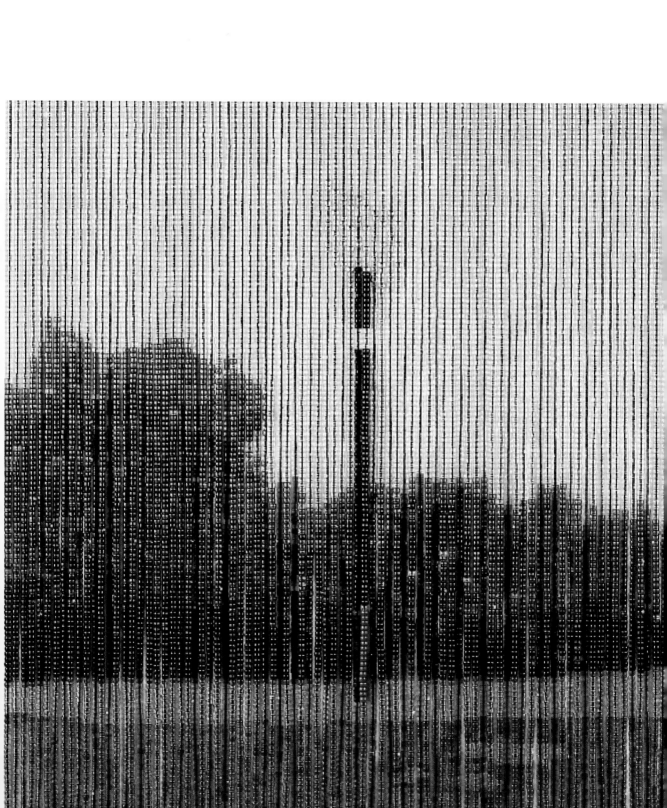

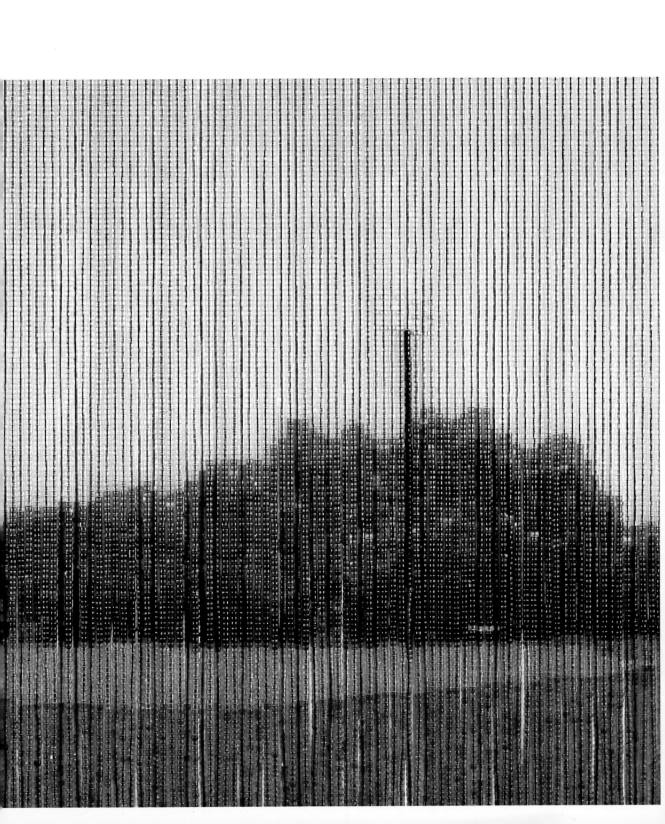

SPONSOR'S FOREWORD

The Fellows of Contemporary Art (FOCA) take great pleasure in collaborating with The Studio Museum in Harlem to present *Kori Newkirk: 1997–2007*. This is FOCA's first opportunity to begin an exhibition outside California, and therefore represents a significant enhancement of our mission. In thirty-five exhibitions over thirty-two years, FOCA has been instrumental in supporting and documenting the work of emerging and mid-career California artists. Eleanor Antin, Wallace Berman, Vija Celmins and George Stone have each been presented in past FOCA sponsored exhibitions. FOCA has presented a wide variety of other exhibitions by curators as diverse as Julia Brown, Howard Fox, Henry Hopkins and Ralph Rugoff. Among our partners in this endeavor have been the Los Angeles County Museum of Art, Museum of Contemporary Art Los Angeles, San Francisco Museum of Modern Art and Hammer Museum at the University of California, Los Angeles.

The present collaboration is especially significant to FOCA as a Los Angeles-based institution because, to quote Thelma Golden, "Los Angeles functions as the inciting incident in his [Newkirk's] work. As an informed outsider, his art practice is inspired by the often confusing, distanced, fractured existence that so defines life in a new city. He told me he didn't know who he was in L.A.: hero or villain, savior or menace, hyperpresent or invisible." The catalogue accompanying this exhibition is the first major publication devoted to Newkirk's work and greatly enhances FOCA's mission to document an artist's work at critical points in his or her career.

I would first like to thank the curator of this exhibition, Thelma Golden, for her thoughtful and insightful consideration of Newkirk's place in the current discourse on contemporary art. I would like to thank Newkirk himself for his cooperation and for his ongoing support of FOCA's mission.

I would like to thank the Board of The Studio Museum in Harlem and Lowery Stokes Sims, former Adjunct Curator for the Permanent Collection. Christine Kim, Associate Curator, and Lauren Haynes, Curatorial Assistant, were invaluable in making this a smooth-running team.

Numerous Fellows helped bring this exhibition to fruition. Thanks go to past Chair of Long Range Exhibition Planning Peggy Lewak and her committee members, and to FOCA Immediate Past Chair Rubin Turner. Stacen Berg and Karl Erickson, FOCA Directors, gave us long hours, constant guidance and much-needed support. Thanks to the energy and enthusiasm of all those listed above; it has been an effortless pleasure to serve as exhibition liaison for *Kori Newkirk: 1997–2007*.

FOCA is unique in that most of the support we give is derived from our members' dues. It is only through our members' support that we are able to bring exhibitions such as this to life. Very special appreciation and thanks go to the members of the Fellows of Contemporary Art.

Geoff Tuck / FOCA Chair (2007–08)
www.focala.org

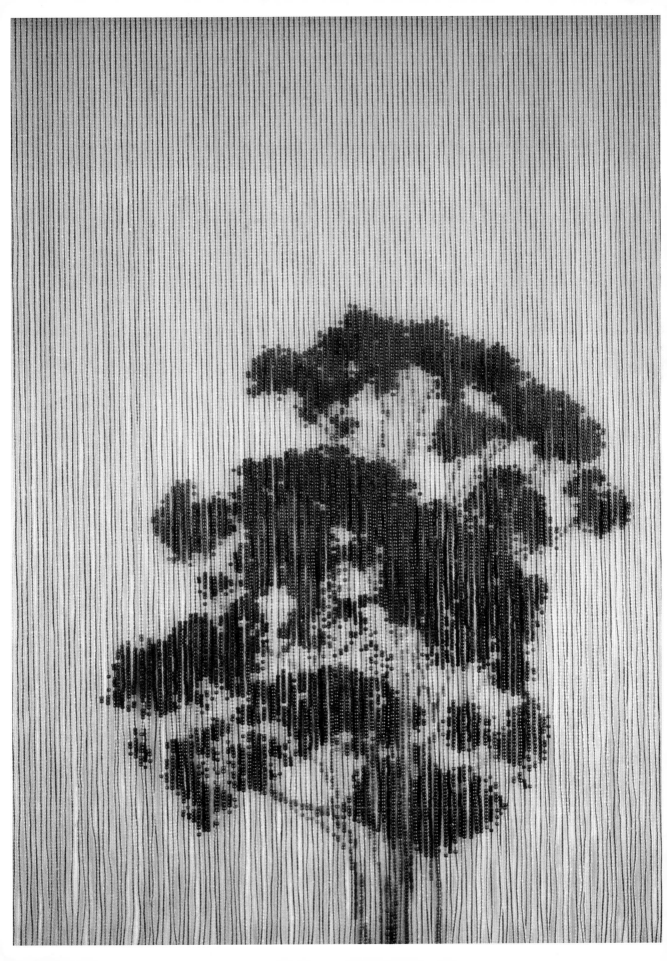

THELMA GOLDEN IN CONVERSATION WITH KORI NEWKIRK

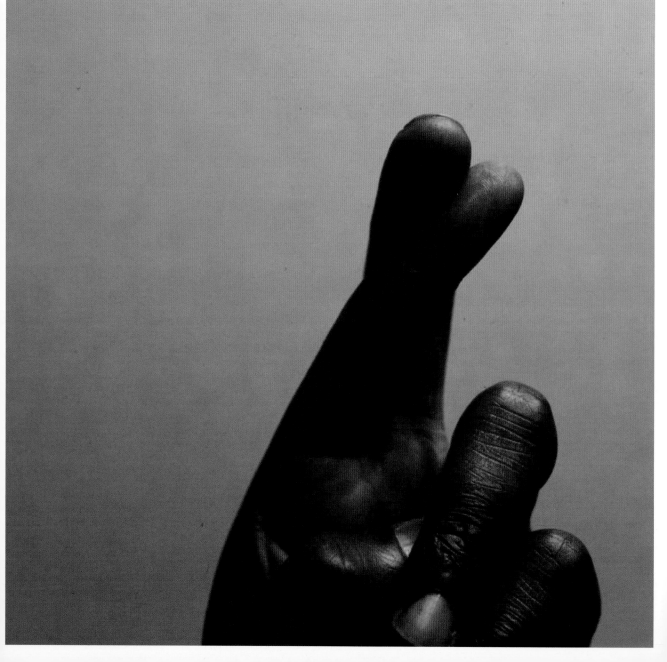

DATE : September 17, 2007

THELMA GOLDEN

Kori Newkirk: 1997–2007 is a survey tracing the past ten years of your studio practice and development. So let's start in the studio. Do you think about work you've made in the past when you're making new work?

KORI NEWKIRK

I keep a lot of documentation of past work up on the studio walls. So I look at it and reference it occasionally. Sometimes I try to recall what I was thinking about and look at how I solved certain problems, and occasionally this helps me solve a current problem. A lot of times I'm just remembering how I got from there to there to here.

TG

So how did you get from there to here? And describe to me what "here" is now. Where are you right now as an artist?

KN

Right now, I feel like I'm in a total state of transition and it's really exciting. I have this opportunity to look back over my shoulder at the past decade, which I haven't really let myself do before. But I'm also looking ahead. What's next is ten million times more exciting to me. I can now expand upon all of this I see in front of me. This is like the edge of the diving board. I have climbed up the ladder and moved out to the edge of the diving board, and in front of me is this much larger expanse than I think I was able to see in the past decade. I'm ready to take a plunge.

TG

What made you become an artist?

KN

I honestly had no choice. I couldn't do anything else. I can't do anything else. I think I would have just still been at home doing nothing if I didn't do this. It was a calling and it's been fraught with frustration and joy and pain and a lot of hard work, but it's been absolutely wonderful. I'm always surprised at what I am able to convey, and I feel really lucky to be able to do this.

TG

I remember the first work of yours I saw. It was towards the end of my time as a curator at the Whitney Museum, after a couple of people told me I should see your work. You sent me a package and the work I remember most was *Channel 9* (1999). I was intrigued by the range of your practice, but particularly by that image. I went back to *Channel 9* when I began thinking about the show that became *Freestyle* (2001). I realized that it intrigued and unnerved me because I didn't have a vocabulary to describe it. The vocabulary I had become so fluent in during the late 1980s and 90s somehow dismantled around that particular image and then your practice generally. So where did you begin? What was the beginning of the conceptual journey into your work?

KN

The earliest work in the exhibition is *Modified Cadillac (Prototype #2)* from 1997. I started playing with pomade near the end of graduate school. One morning I happened to open up the medicine cabinet and unscrew a jar of it that I'd brought back from England many years before. The smell was particularly strong and resonant, so I'm standing there looking in the mirror, thinking I'll put a little in my hair. Suddenly the smell just took over. I immediately started thinking about my sister getting her hair done every Saturday morning with the hot comb in the kitchen, and me laying on the floor watching *Soul Train* with my brother in central New York. I thought, "Wow, that smell is automatically bringing back all these memories." There's got to be some way to put that out in the work, to share that. I'm not the only one who's going to have that visceral kind of response, because I know that I'm not the only one who's ever smelled and experienced that.

TG

And they're made with your hands.

KN

Yes, they are made with my hands, smeared on the wall, and with some tools sometimes. They're not meant to exist permanently. Prior to that, I was always really interested in the materiality of things. I played around with soap a lot as an undergraduate, trying to build things with clear glycerin soap to light up. This was after an exchange I did in England. I saw all

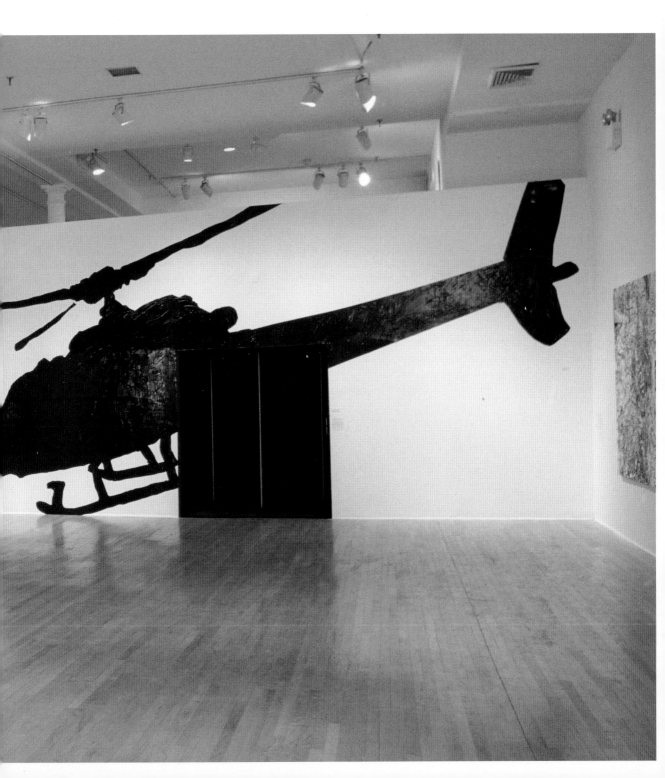

the earliest Rachel Whiteread works and all these other pieces that dealt with light and text and different materials, and was just blown away. I just realized that my reality is about messing with things, putting my hands in things and seeing what happens. And the idea determines the material; the idea comes first and tells me how it wants to be expressed. This is what happened with *Cadillac*. I thought, "How can I talk about this?" There was the one made from hair, and then I progressed to pomade, and then to the idea of landscapes and beads and braids. It tends to go in that way. The work tells me how it wants to be expressed.

TG

Where do the images come from? The one you made for *Freestyle* was of a helicopter.

KN

I like that those kinds of work exist only for the time that they're up, and then they're gone forever. If you miss them, you miss them, and that's maybe how I feel about myself, in a way. Maybe they're about mortality and maybe they're about my mother always telling me that she'd be talking to me and then she'd turn around and I'd be gone. I look at them that way, that they're just there and then they're gone. I don't think everything needs to be around forever. I give you the smell and the material and the image, you get it and then it's gone. So it's a lot about memory.

TG

Many artists have one way in which they work. You work in many different media, but it seems there's no way to discuss your practice without acknowledging the invention and innovation of your two-dimensional beaded sculptural curtains. Can you talk about how these works developed?

KN

They began also in 1997. I was in Skowhegan, Maine, right after graduate school. I spent nine weeks in the woods, not knowing what I was going to do. I'd brought a bunch of different materials — without any particular vision. I just thought I'd go out there and see what happened. For some reason, I brought along a few packages of braids. I was in my studio, not making much work and getting into a lot of trouble for that. That was

the year that Venus Williams broke through to the U.S. Open finals for the first time. I had never really been a tennis fan, but I remembered watching and being fascinated by a story about Venus and Serena on *60 Minutes* many years before. I was reading all these articles about Venus, but most of them were about her hair, beads and braids, and how other players were worried that a bead might fall on the court and they'd step on it and break an ankle. Her blackness, signified by her hair and its problems, was the first and most visible thing that they talked about.

I thought it was interesting, and then I looked over and there were some braids. I immediately thought about Stevie Wonder in the 1970s. And there's an episode of *The Facts of Life* where Tootie has fake braids and she's a model. My mind went to seventh grade, when we were briefly living in Jacksonville, Florida, in the 1970s. I remembered seeing girls and boys with braids and wanting to have braids as well. I also thought of the beaded curtains that hung in my relatives' apartments here in the city, and to the boys with little conch shells walking up and down 125th Street. All of that flashed through my mind and I visualized some sort of image on the back of someone's head made with beads and braids. I went to the local Wal-Mart and found some beads and jury-rigged a sort of armature. I strung some beads on it. They were all white and blue and opaque and I thought I would make clouds, but it just didn't work. I thought it looked too Native American, almost too ethnic in a way that I felt I couldn't talk about. I didn't necessarily have permission to go in that direction, so I stopped and put it away for a few years. Then I had my first show (*Midnight Son* [1999] at Rosamund Felsen Gallery in Los Angeles [Santa Monica]). It popped into my mind again that maybe it was time to figure out that idea, and from that came *Jubilee* (1999).

TG

What exactly is *Jubilee* an image of? And how did you move from the ethnic, folksy craft that you didn't want to the hyper-visual abstraction combined with figuration that defines that work?

KN

It is basically an image of a wall of fire, which goes with the earliest works — *Channel 9, Channel 11* [1999] and other

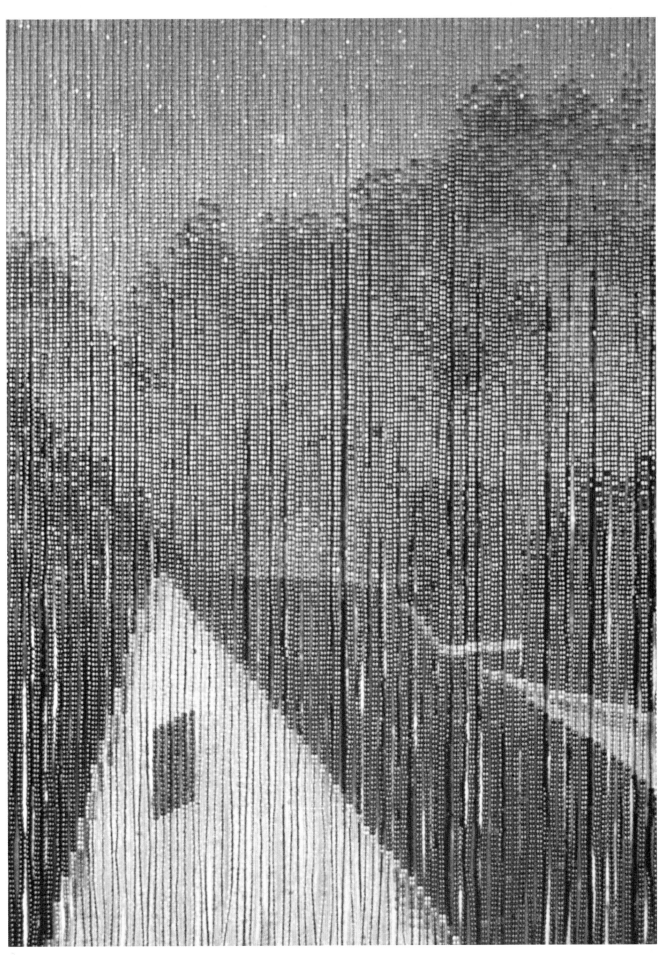

works from that time – that were about my response to living in Los Angeles.

TG

How long had you been in L.A. at that point?

KN

I had been in southern California since 1995, but in L.A. proper since 1997.

TG

Where were you when the 1992 L.A. uprisings happened?

KN

I was actually in England in a liquor store and I heard it on the radio. I was amazed, but not surprised. I knew that something like that would probably happen. I had never been to L.A., but I fully understood the idea of something like that happening. Culturally, though, my friends were not able to comprehend the idea of a civil uprising in that way.

TG

So then you got to Los Angeles, and these works were your response to being there?

KN

They were my response to being in Los Angeles and what I felt was my place in it. I was also teaching high school in South Central at the time. I had conversations with my students about what they called themselves, what I called myself and how they felt about their representation in L.A. It was very convoluted. They tended to see themselves as suspect on television news and that was something I could relate to even though I hadn't been there that long. But I'm a black man in the United States and my representation is tied to that. From that came *Jubilee*, the first attempt at a beaded curtain. It actually looks rather pop, but that sort of just happened.

TG

Can you explain the title?

KN

Well, fire is sort of universal. It's a beautiful and dangerous

at the same time. In a way it's very celebratory, and that's how I saw what happened. It represents a type of rage and anger and all the frustrations that caused and led up to that uprising. It also represents the idea that L.A. is always burning – literally, figuratively and in so many different ways. There's also a book, *The Fires of Jubilee* by Stephen B. Oates, that is about Nat Turner's slave rebellion. I kind of took the title from that, which is also interesting because there is some family history around that. I wanted to talk about the joy and sort of wonderfulness of fire, as well as the danger. It's very mixed I think.

TG

How did the curtains develop after that time?

KN

After *Jubilee* and *Nowhere* (1999), I put the curtains away for a year and a half or two years. There was no reason to make them. Something told me I needed to be free of the curtains. There was a lot of other work I needed to get out of my system. When I had the first opportunity to have my work shown at The Project, I thought maybe it was time to make a curtain again. I made three, but I realized at that time that the themes from the first show were no longer relevant or interesting to me in the same way. I wanted to speak about something else, identity, sort of. This turned into the narrative-based landscape, and from that point on I explored that part of my history.

TG

I'm very intrigued by the landscapes, which seem to focus on houses, structures and the landscape that adjoins them. More recently, the images move into the pool and involve water. Tell me about both these kinds of suburban/pastoral/ still life images. What inspired them? Are their references real or imagined?

KN

They are all inspired by the reality of growing up in central New York, in a place that looks like many of those images, with green trees, cows and these weird semi-suburban spaces. They're inspired by the idea of isolation and its beauty and strangeness. In central New York, the houses and landscape actually look like that, but I don't want the images to be identified with central New York alone. They're everywhere and nowhere.

TG

So it's like autobiography written in landscapes.

KN

In trying to combine both sides of my upbringing — the urban side of Harlem and the Bronx, which was the weekends and the summers, and the country side of small towns upstate, which was during the school years — I have mostly based the works on landscapes in central New York because I felt that the materials were urban enough. With a few exceptions, the materials are the city and the imagery is the country.

TG

Do you think of the curtains as paintings or sculptures or neither?

KN

I deal with the formal language of painting, even though I sometimes consider them sculptures and sometimes consider them paintings. I prefer to think of them sculpturally, but there is definitely a strong painterly quality to them.

TG

When did you actually work in paint?

KN

A long, long time ago, mostly as an undergrad. But I fought it at that time too. I've always considered myself a non-painting painter who sometimes makes paintings, but with absolutely no paint.

TG

What kind of paintings did you make?

KN

I made very conceptual, slightly abstract paintings.

TG

Were they good?

KN

I think they were pretty darn good. People told me they were pretty darn good.

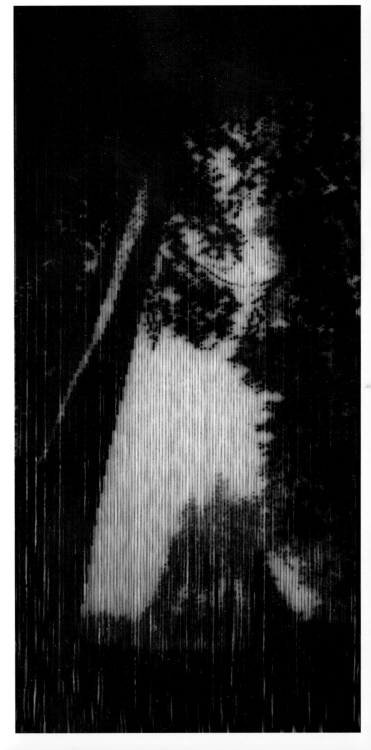

TG

And why did you stop making them?

KN

I was surrounded by people doing tenth-generation Abstract Expressionism, and it just drove me up the wall. The romantic notion of what it was to be a painter was being flung back and forth around me. I found it abhorrent.

TG

Going back to the curtains — how do you make them? Do you start with preparatory drawings?

KN

No. Most of the time I take, find or appropriate an image, or I just run around with a camera. Once I find the image, or when the image tells me that it needs to be a curtain, I run it through the computer briefly. There's no editing at that point, no computer tricks. I just resize it to the size of the potential curtain. I create a transparency, which I then project onto a large piece of paper, and I make a cartoon from that — a very, very loose line drawing. At that point, I put the aluminum with the braids strung right in front of the paper, and then I start beading from the bottom. When I reference the picture, it's not always exact, so things can change. It's a very labor-intensive process.

TG

You also work in other media and I'd like to talk about some of the other bodies of work you've created. There's a lot of work involving basketball. While it's easy for me to read these through the simple tropes of black masculinity, how do you see this body of work?

KN

That's what it does in a way — you're right. Beyond all of that, I'm tall black man, and naturally it has always been assumed that basketball is my sport. It's not.

TG

Are you a fan?

KN

I'm not a fan.

TG

Not at all?

KN

Not at all. Basketball seems to have been thrust upon me. It might hearken back to the idea of the romantic notion of a painter — something I need to rally against. In my mind, it's more like a protest against the idea that I should do something because of the way I look.

TG

What are they about? Tell me about *Bumper*, a photograph from 2001.

KN

Bumper is the dual photograph of two balls on the basketball court. It's about the loneliness of the sport, or what I see as the loneliness of my place in the sport, based on the assumption that I should playing this, but am the worst at it.

TG

And *Closely Guarded* (2000-01) . . . ?

KN

Yes, the never-ending game. You score some points — the ball travels through the net and comes out the other end, so you've lost what you gained. You can never really win. There's a whole current in my mind about science and cloning. I feel that the molecular structure of every fiber of my being makes me look like this, and leads to the assumption that I should like basketball. The men in the street outside of my building, the homeless men, always asked me if I saw the game the night before. Just walking down the street I get asked something about basketball, and it seems to shock people that I don't like it.

TG

So, in some ways these works are a reaction to your ambivalence toward what you are supposed to own.

KN

Very much so. I didn't want to make work that was slamming basketball. I wanted to make this work, which spoke

about my ambivalence and desire not to play basketball. I'm not a part of it, but it's assumed that I am, and that's why one of the first works in that series was *Assumption* (2000). That title gives it all away.

TG

I love encountering works that I don't understand. In trying to understand your work, I see that your path as an artist is always about breaking away from what fits . . .

KN

Not consciously.

TG

There's a language you own, but you're also looking ahead. I was intrigued by the show in 2003 at The Project, of what I always refer to as the "white work" (which obviously has multiple connotations): the shark, the snow, the white light. I'm very curious to know how you see those works.

KN

I'm very curious too, partially because I don't know. Once

again, I just had to do it. I felt that I didn't want to make curtains at that moment. There were other things I needed to talk about.

TG

And *Haywood* (2002) is a photograph of you...?

KN

Yes, it's me naked in the snow.

It was taken in 2001 or 2002 in Washington state. I was in Seattle working on a project at the Henry Art Gallery and I came across a photograph by Sarah Lucas in the True Collection where she's opening a beer and the foam is in her face. I was just blown away. Out of all of the work in the collection, why did I respond to that? I felt that I needed to get out and do something. I wanted to roll around in the snow and take my clothes off. I don't know why. The curator and other collectors made it happen. The next thing I knew, I was deep in the woods with no idea where it was going to lead or what it was about. I just felt that it was really important for me to be in the snow. I then began thinking about what it means for me to be in the snow and how I felt about growing up in a place where it really, really snows.

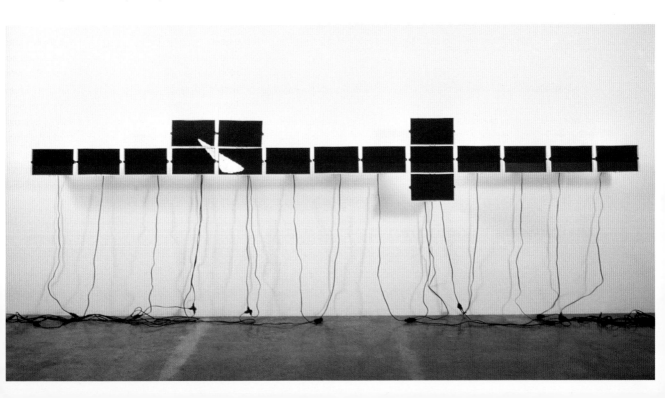

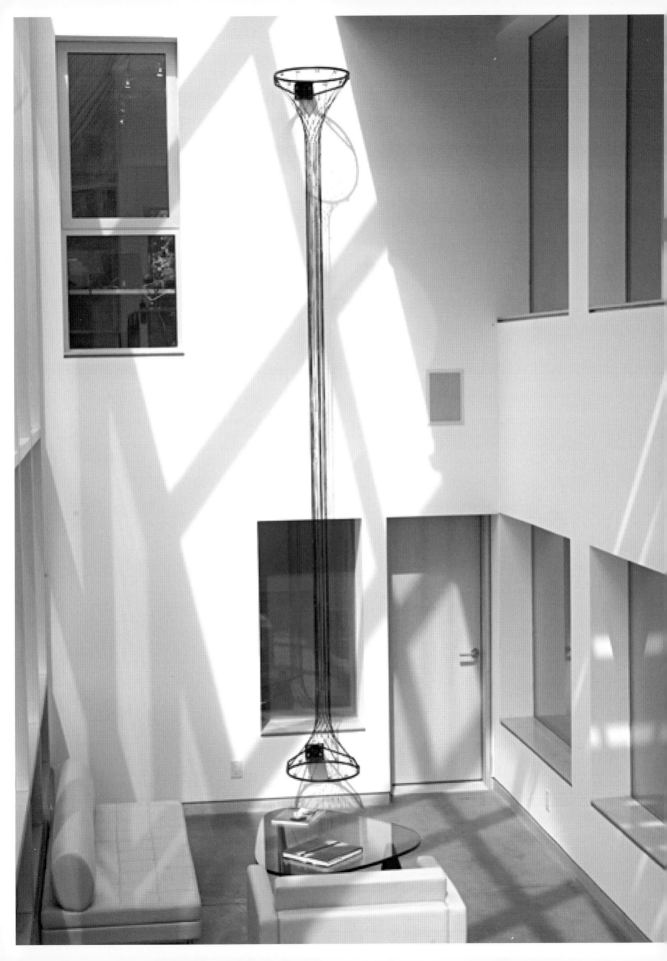

I thought about the thir
like, "Put a hat on, you'
of how we needed to p

gs my father would say,
e not Nordic," and tales
otect ourselves.

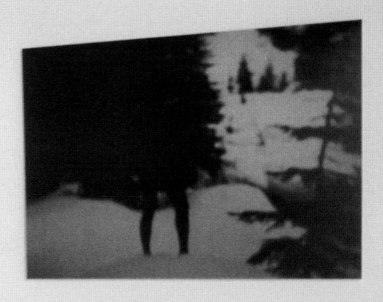

TG

Who? Black people?

KN

Yes, as black people we need to protect ourselves from the snow – there's this stereotype that snow is just not "natural" for us. Yes, we had to deal with it, but it's not supposed to be natural because we're African. So, put a hat on, proper boots and all of this stuff. I loved the snow, but it was still something quite foreign and it didn't feel natural for me to be in it.

TG

How did the works evolve to include a shark?

KN

It's a really tough body of work for me to talk about because I still don't quite have it all down. It's a lot about my father and the things that he said. It's also about predators, invasion and danger. I think about it as two white dangers – the snow and the great white shark – and how they relate.

TG

With a third unnamed white danger?

KN

Yes, unnamed, but the first two are white things that can kill me as I am.

TG

What's startling about *Haywood* is seeing your black body. Are there some changes in the way you look in the whiteness?

KN

But the snow is also invisible.

TG

It is.

KN

It's invisible, but it's also right there.

TG

Invisible but very present. What I loved about it is that it is

so "throwback." People stopped talking about "whiteness" in the 1990s. *Haywood* takes us through an intriguing thread in your work – the images of your own body. I have always been amazed by the candor, immediacy and intimacy of those images. But I'm also amazed, in some cases, by the outrageousness, which is born of equal parts artistic passion and very healthy narcissism. Talk about you as your subject.

KN

It's always easy to put myself out there, and it has taken a long time for me to become comfortable with myself. I think the photographs are a little about that and a little about me as a subject. It started back in 1993, the first time I was able to take my clothes off in my work.

TG

What work was that?

KN

It was a work made with Lite-Brite, my first self-portrait using photography. I took my clothes off, played around with the Lite-Brite and talked about childhood memories, dreams of the future and desire. From that point, I felt comfortable enough to see myself in that way. Every so often, I want to talk about race, and I realized that the only way to do that was to place my body in the work.

TG

What are you talking about when you use your body?

KN

My place in the world – whatever that means and wherever that is. My place in society as a black man. I tend not to want to be identified as an individual in the photographic self-portraits. I feel there are larger issues than me being addressed, even if I was not able to identify them. This might come from thinking about Lorna Simpson's work – it isn't necessarily about the individual. It speaks to much larger archetypes. It's about a black body that's anonymous in a way. I don't know if my work is about the anonymous male body; it's more about the symbolic body.

TG

Is this body of work about desire, your own sense of it?

KN

It's about desire in so many ways — my desire to be visible and yet invisible. But I'm all about self-love, which took a long time to realize. It just expressed itself in this way. I think I'm kind of cute, I guess, and I like my body and think I'm in touch with it. I used to be an athlete, a super athlete, and I think that has something to do with it as well.

TG

What makes you then put yourself in your work?

KN

I have no choice. That's the only way I know to get what I want across. My idea of self and identity goes back to the 1993 Whitney Biennial, which was one of the most important shows of my career. Deborah Kass once told me when I was making those paintings that someone will always make abstract or conceptual paintings better than mine. People will be doing that forever, and when I start making work about myself, then I'll make something that no one can do better. No one can make a better Kori Newkirk about Kori Newkirk than Kori Newkirk. So with that I was almost given permission. A big weight had been lifted off, and from that point I've been able to put myself in my work.

TG

That's interesting, because one of the terrible legacies of identity politics and work that investigated it from the 1980s and 90s was that that work was about identity in a large way, but often got understood in a small way. Everything was misunderstood as autobiographical.

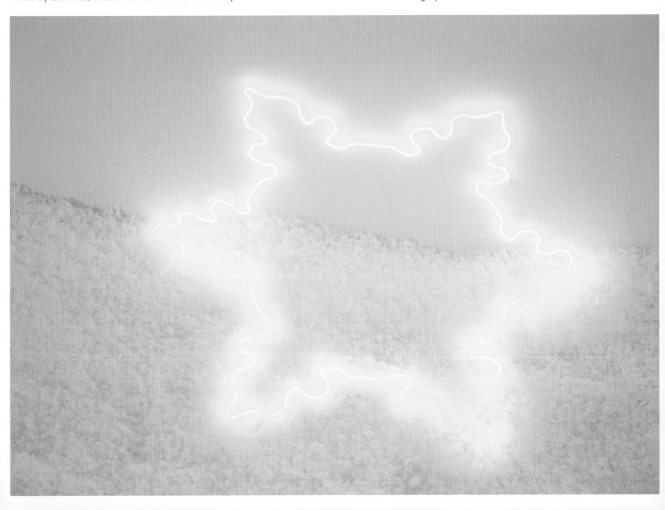

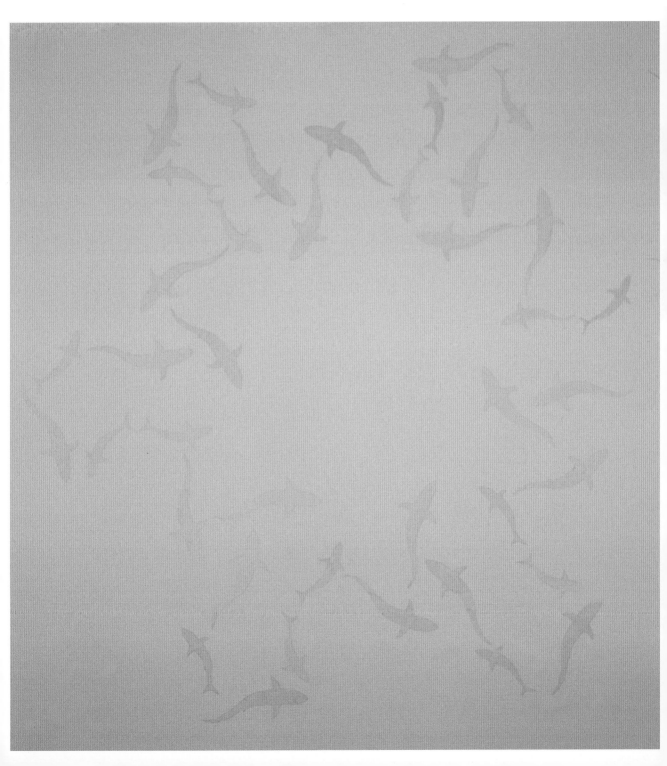

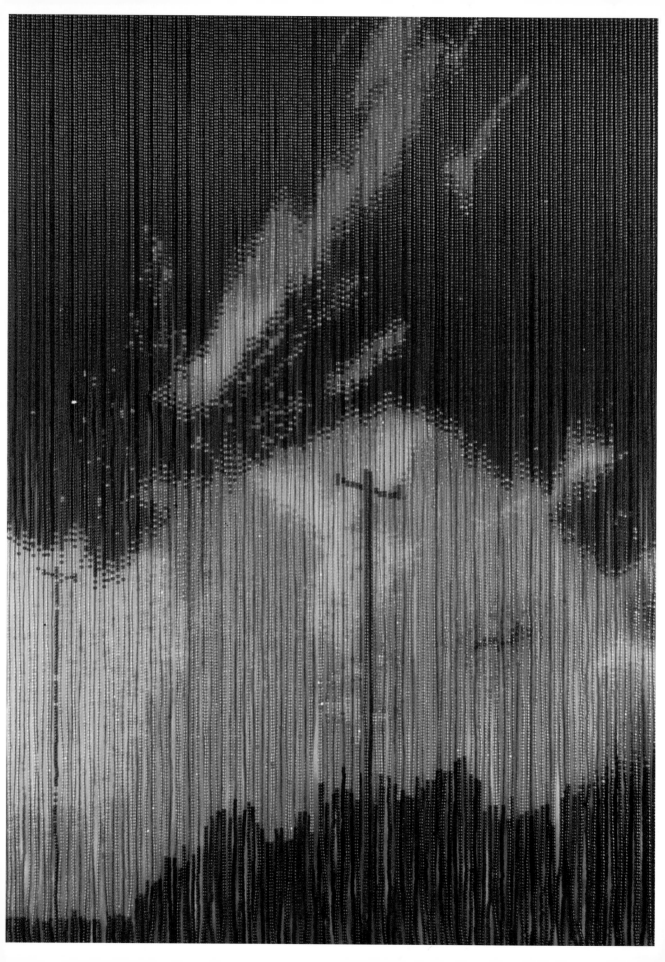

But you seem to have been able to understand the problems of the readings of identity politics. You make work about race or you make work about gender, but you are also always speaking about yourself. At the same time, the language around your autobiographical work functions on both macro and micro levels — big and small issues.

To me, there's something important about your work that's informed by Los Angeles, but I know that you are ambivalent about that, being a New Yorker.

KN

I was just having an argument about that last night, saying that I just live in L.A. I'm not of there.

TG

I know you feel that way, but there is something about your practice that is informed by the deep roots of L.A. Conceptual art. I see it in your work, but also I see it in your understanding of the city. As you remember from the first time I came to see you there, I was amazed by the way that post-uprising L.A. informed the work of a lot of people. Some had had a generic sense of local art scene, but then after the uprising gained a new sense of the urban complexity. My first way into that was through the work of Daniel Joseph Martinez, which led me through a trajectory of the different versions of Los Angeles, the practices informed by them and the way those practices interacted. I remember distinctly coming to see you for the first time. The New Yorker that I am thinks of Los Angeles through its stereotype — the lovely, sunny West Side. I came in and I rented a car. You kept saying, "I'll come and meet you in the parking lot," and I said, "I'm from New York. I work in Harlem." And you said, "No, I'll come and meet you in the parking lot." When we got to the street it looked like a movie set of skid row.

KN

It is skid row.

TG

It's like the deep, dark underbelly of the city, which was one layer you existed in. The second layer was when you were a high school art teacher in South Central, deeply invested in your students. But because of your students, you had a deep sense of the popular culture there. You could talk about Los Angeles and more importantly, you began showing this work there. In that context, the sublime nature of your work is, I think, in some ways a Los Angeles phenomenon.

KN

I think I fight that thought mentally. Maybe I just resist too much all these things that seem so ingrained in my practice. I always want to go against it; I always fight myself. Am I a Los Angeles artist? Do I want to be a Los Angeles artist? I love Los Angeles. I'm there, but I'm from New York.

TG

So it's about a "void of silence," which is also the title of one of your L.A. works.

KN

It's really about luck and lying. It's about the idea of someone crossing their fingers for luck, but you also cross them when you're lying.

TG

Tell me about some of the artists whose work has inspired, informed or instigated aspects of your practice.

KN

My work is informed by the sensibilities of Fred Wilson, Glenn Ligon, Carrie Mae Weems, Gary Simmons, Adrian Piper, David Hammons, Kerry James Marshall, Daniel J. Martinez, Pat Ward-Williams and Eva Hesse. I'm also influenced by James McNeill Whistler landscapes and J.M.W. Turner. But that list changes everyday. I deal with concrete issues but my media are fluid, so my influences shift with the fluidity of the media.

TG

Those seem to be influences that you've been able to look at and understand and redefine in your own voice. When I think about those artists and your practice, there are clear relationships. There's a rich dialogue.

KN

Yes. And also, incredibly, I used to be a staunch Minimalist.

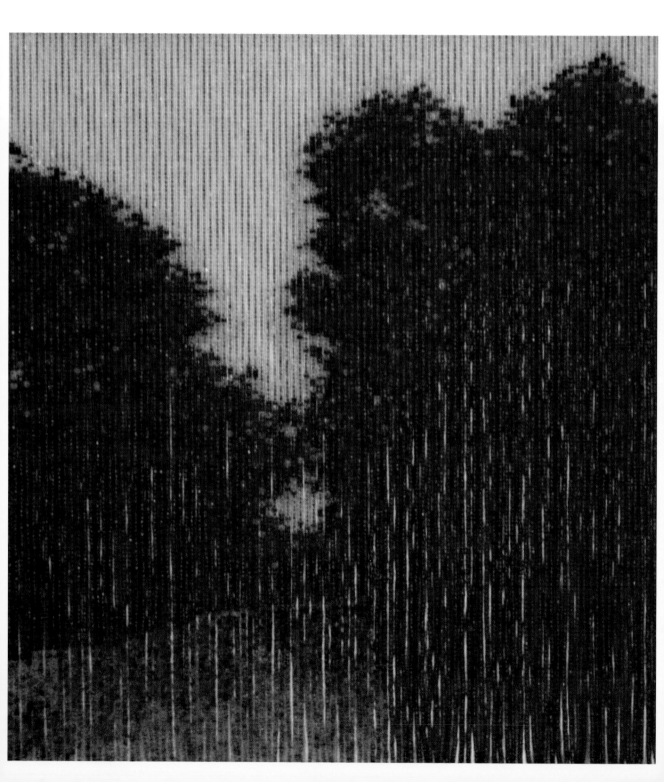

TG

When? Before or after you were an abstract painter?

KN

A little bit before, a little bit after and still to this day. I think there are some really important aspects of Minimalism, which are reflected in the distillation of my work. There's a detachment I have responded to, and it is still inside of me. I try to be incredibly detached from the work, much to my detriment mentally and emotionally. Sometimes, when I have to talk about it, it seems so difficult, because I have created a language to describe these things in my mind.

TG

Well, in some ways, the language you've created is the work itself. That's your language. That's the vocabulary, the work. The question is whether you can describe it, but it seems the vocabulary is there. How do you incorporate the medium of video into your practice? Tell me about what video means to you now.

KN

I've always thought about video, but there was no reason for me to work in that medium. I don't investigate a material until it's right, until something says to me, "I need to be made in this material." The only way to talk about the things that were going through my mind was through the moving image. At that time I found myself thinking about how I can finally show my face and my identity as Kori, as compared with the photographs and the other images of me in which nothing is clear. Finally my visage is in focus, but in an otherworldly way. In my mind, that's what I am.

TG

What's *Bixel* (2005) about?

KN

Aliens. Well, the idea of alien-ness. It's a culmination of the curtains and all of the work before, the location, blue sky, estrangement. It's really about privilege and failure and transformation. I've always had a fascination with the color silver and what it signifies, hence the glitter pouring out of my mouth. I wanted that idea out there in the world.

TG

What did it feel like to make it?

KN

It was totally liberating and extremely scary. I'm not normally worried about the critical response, but I just . . . I took the camera and was all by myself, no tricks. It's all about the purity of the medium. I just set the camera up and did what I wanted to do. And what I had to do. What I thought I needed to do. That was actually really liberating. I was able to play again and bring in all these other things that were going through my mind and did not lend themselves to curtains, photography or sculpture.

TG

And you're working on a new video for this exhibition.

KN

I am, a sort of short transitionary, transitional video.

TG

What is it about?

KN

Well, the work is moving away from the country and the suburbs.

TG

Where is it going?

KN

It's coming back to the city.

TG

Which city?

KN

The idea of the city, so in some way there's a migration. The migration now is moving slowly back from the suburbs to the other side, back to the city.

TG

Why?

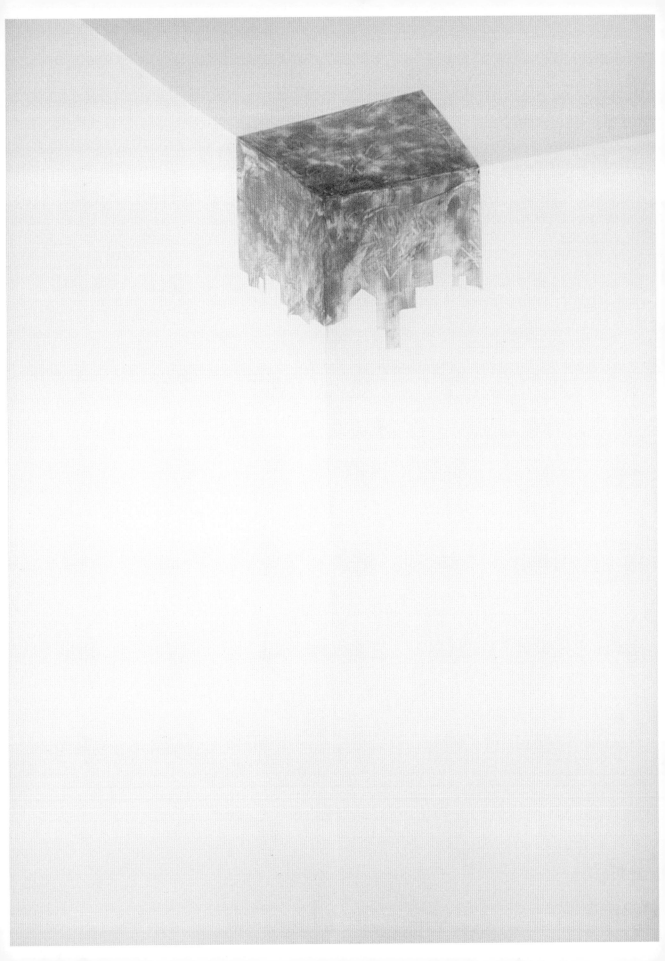

KN

The work is telling me to. In the same way that the Jeffersons moved on up, I'm moving on back to the idea of the city.

TG

You're an artist because you felt there was nothing else you could do. You make work that's about your history as it relates to the urban environment, the rural environment and you as you know yourself and are understood by society. You make it in a variety of media and you've mentioned that you're in a process of transition. You're moving forward. It seems like you've already moved around a lot. Where ultimately do you want to land, artistically and intellectually?

KN

I DON'T THINK I EV

I THINK I JUST NEED T

IT GOES BACK TO THE

AGAIN : WHEN THEY S

THEY SINK AND DIE.

THAT'S HOW I SEE MY

R WANT TO LAND.
KEEP MOVING.
SHARKS
OP SWIMMING,

ELF.

IF I STOP MOVING, IT'S

SO I DON'T THINK THE
WHERE I EVER WANT
EVEN THOUGH I HAVE
FOR QUITE A LONG TI

I DON'T KNOW WHERE

I JUST KNOW THAT IT
GET A LITTLE MESSIE
SMARTER, A LOT MORE
A LOT MORE CONFUS

OVER.

E'S A PLACE
O STOP,
PAUSED
E IN LOS ANGELES.

IT'S GOING TO END.

S GOING TO
, A LITTLE
AMBITIOUS AND
G.

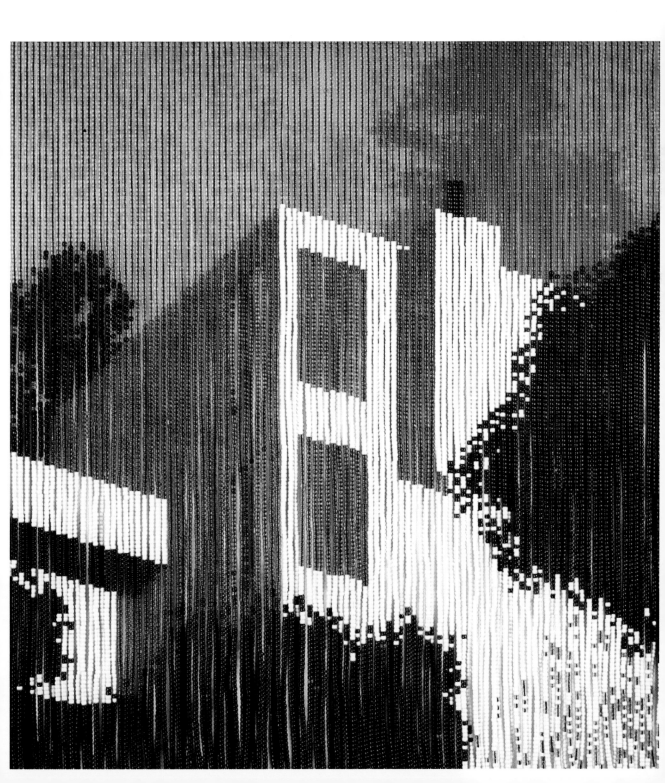

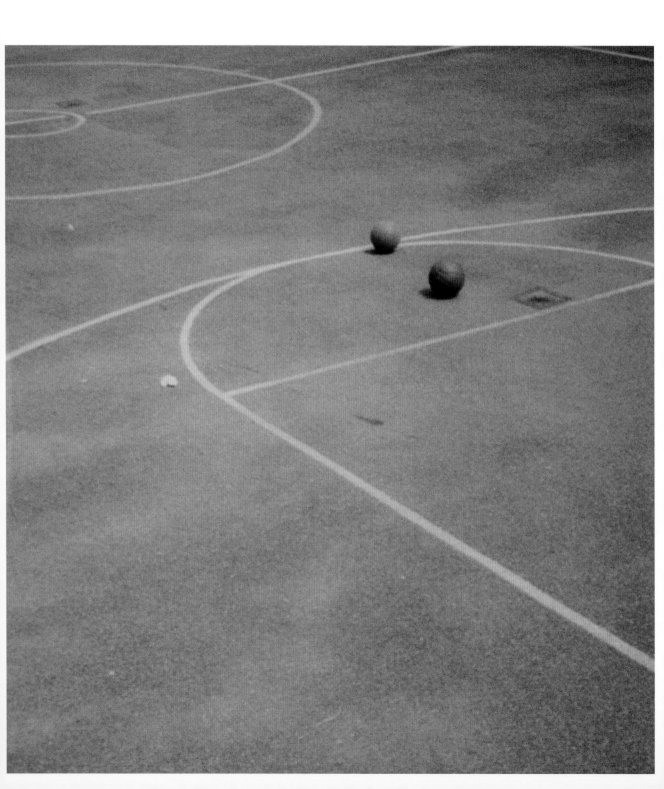

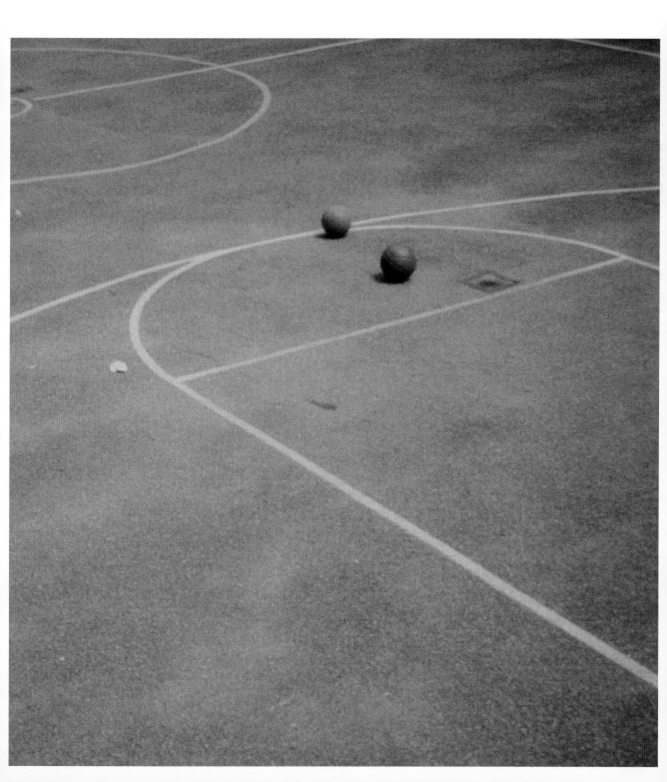

FOOTNOTES

1 Several friends and colleagues have lent their time, thoughts and words to this essay. Thanks to Hannah Feldman, Kianga Ford, Bibiana K. Obler, Krista A. Thompson and the editors at The Studio Museum in Harlem for their incisive comments on previous versions of this text. I have also benefited from conversations with Blake Bradford and Darby English, as well as from the research assistance of Melissa Daniels at Northwestern University, Penelope Santana at The Project, my father Huey Copeland I and, of course, Kori Newkirk.

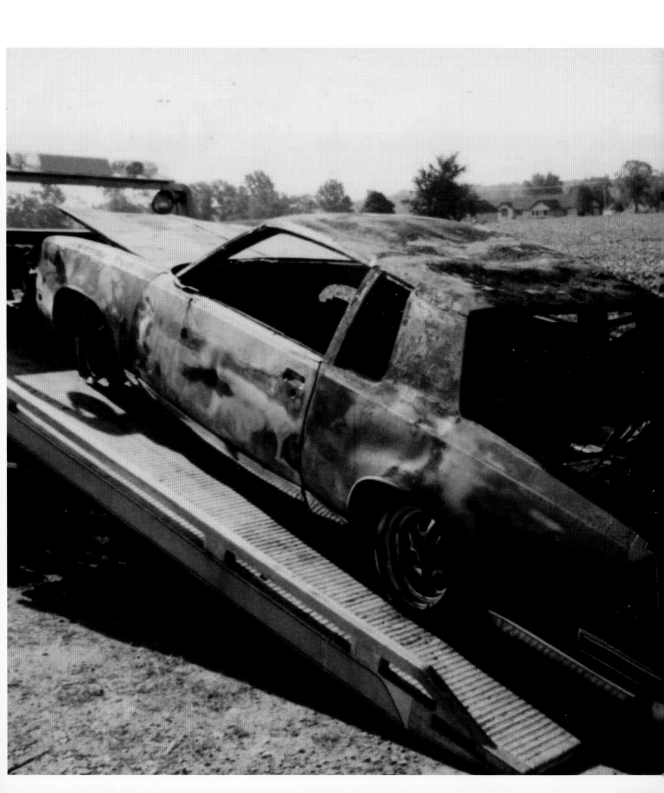

A FAMILY RESEMBLANCE

HUEY COPELAND

This is an essay about Kori Newkirk, his art and the steps both take toward disidentifying with the presumed coordinates of African-American male subjectivity. It is a modest attempt to map out the critical postures that Newkirk's varied body of work enables and to consider how he has refashioned dominant cultural models for himself and his viewers over the past dozen years. Given the artist's complex relationship to identity politics, the calculated opacity of his signature pieces and my own interest in such positions, this is a reasonable tale for me to tell. I want to begin, however, with a subject even closer to home.

My father was obsessed with Oldsmobile Cutlass Supremes. Maybe he loved them because they seemed like the most stylish carriage a self-respecting black father could still justify as a family car, maybe he simply had a taste for their shark-like contours, or maybe they seemed like just compensation for days spent managing the floor of an automotive plant in a white midwestern town. Whatever its roots, the attraction was strong, if in no way unique. Although my mother was generally content to drive whatever hatchback was put in her path, she too was "touched," and together my parents purchased a series of Cutlasses beginning in the early 1980s.

The first one I can remember was black with thin, elegant red stripes running along either side. I'm not certain of this cruiser's eventual fate, though I imagine it went the way of the next two Supremes that rolled up our driveway. The second was light blue with a dark blue hard top. To me as a child, it seemed impossibly long, and the only thing more striking than its presence was its sudden disappearance one Saturday morning. Thieves were blamed and the police dutifully did their work. But in the case of our third Cutlass — a silky gray vehicle that began to smoke one July afternoon — the culprit would be more difficult to pin down.

I was eleven at the time, maybe twelve, and we were all comfortably situated in the car — father, mother, sister and me — en route to visit relatives in Arkansas. Soon after the

(fig. 2) • Kori Newkirk • I Come from a Long Line of Cadillacs • 1995

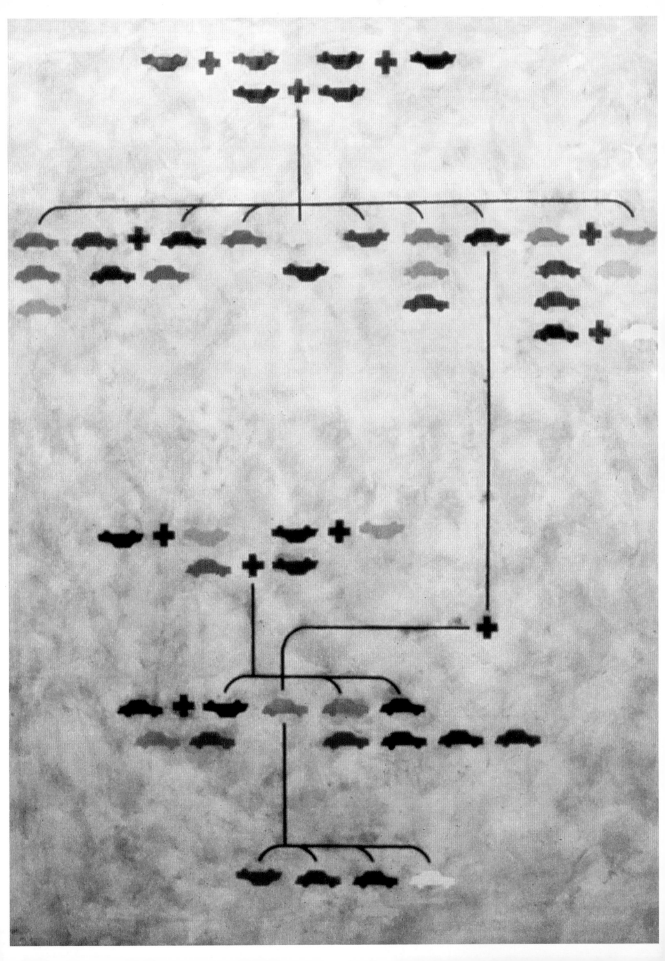

(fig. 3)• Kori Newkirk • Higher Standard (Red Bone Cadillac) • 1998 052

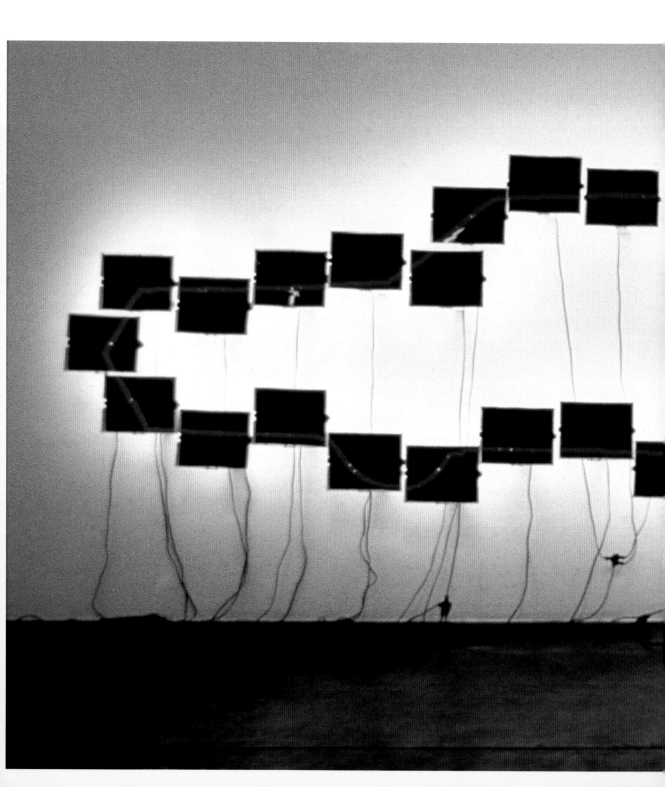

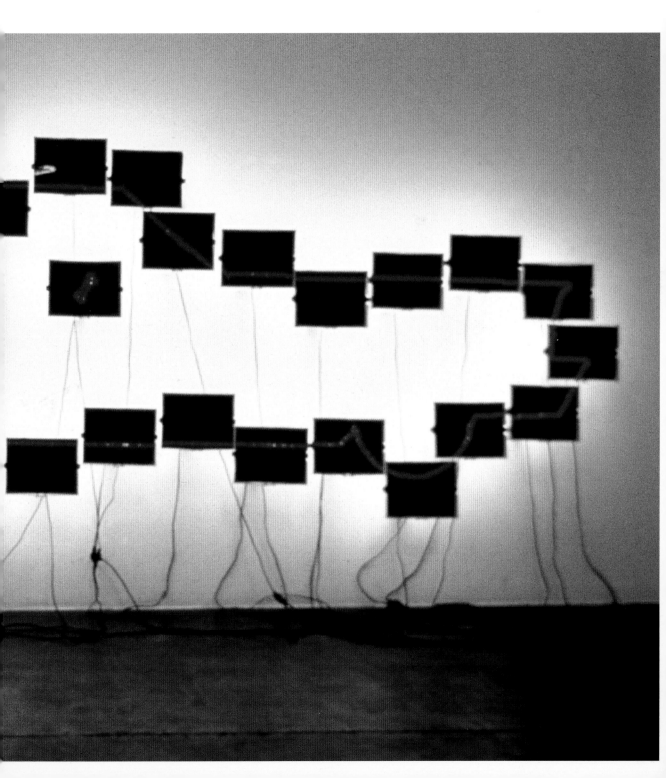

2 My words here are meant to echo those of hip-hop artist Rakim or, more accurately, with critic Paul Gilroy's use of them in his essay "It's a Family Affair." The germane quote reads: "I am excited, for example, by Rakim's repeated suggestion that 'it ain't where you're from, it's where you're at.' It grants a priority to the present, emphasizing a view of identity as an ongoing process of self-making at a time when myths of origins hold so much appeal." Gilroy's essay offers a moving critique of the patriarchal family as the ground of solidarity among black subjects, which speaks productively to the development of Newkirk's practice and my approach to it. See Paul Gilroy, "It's a Family Affair," in *Black Popular Culture: A Project by Michele Wallace*, ed. Gina Dent (Seattle: Bay Press, 1992), 311.

3 Newkirk as redacted in Alice Thorson, "Drawing a Bead on Art: Kori Newkirk Raises Consciousness — and His Prices," *Kansas City Star*, May 26, 2002.

smoldering began, my father pulled over onto the shoulder of the interstate. In the five minutes that elapsed after his feet hit the pavement, he opened the hood, failed to extinguish the engine and calmly hustled us a hundred yards down the highway, where, astonished, we watched as the Cutlass burst into flames. The next time we saw it was at the insurer's office. Propped up on a tow truck and backed by a verdant landscape, the thing looked like an ashen wreck, a cartoonish shell of its former self, yet my father's allegiance to the make would end only when a design overhaul rendered the new models altogether unrecognizable (fig. 1).

In recounting this story, I like to imagine that Kori, more than almost anyone else, knows where I'm coming from and gets where I'm at, 2, not just because our blackness and gayness and middle-class angst led us to analogous pathways out of suburbia and into the art world, but because he too is still trying to make sense of what it means to come from a clan of automotive obsessives. Kori is descended from a long line of Cadillacs, men and women who take after, have taken up with or have been taken over by that iconic American brand. This, at least, is what the title of one of his earliest works straight-

forwardly declares. Executed in 1995 and measuring 4 by 3 feet, *I Come from a Long Line of Cadillacs* is an encaustic on wood panel that represents the artist's forebears with mutely colored silhouettes: upright cars for living relatives, overturned ones for the deceased (fig. 2).3 In its diagrammatic tidiness, this work eschews names, dates and genders, retaining the conceit of the family tree while effectively abandoning its logic; here, affinity, not filiation, is the name of the game. Couples are few and far between, roots are easily confused with branches and, rather than flowing from top to bottom in unbroken lines of descent, this genealogy seems to move in several directions at once, embedding the Cadillac name within Newkirk blood in forms as emptied out as my father's final Cutlass.

These days Kori does not drive a Caddy — they no longer suit his taste, perhaps they never did — but the reference resonates sufficiently within the culture at large and in the artist's imagination to occur with some regularity in his early work of the late 1990s. Newkirk profiled the vehicle's outline with red Lite-Brites and silver gelatin prints (fig. 3), multiplied and dispersed it in fragrant black pomade on sheets of white paper (fig. 4), and even sprawled the Cadillac logo across a gallery wall, its

4 My description of this work is informed by Alice Thorson, "Drawing a Bead on Art: Kori Newkirk Raises Consciousness – and His Prices," *Kansas City Star*, May 26, 2002.

5 See, for example, the important account of this trajectory in Thomas Crow, "Modernism and Mass Culture in the Visual Arts," in *Modern Art in the Common Culture* (New Haven: Yale University Press, 1996), 3–37.
6 William H. Grier and Price M. Cobbs, *Black Rage* (Reprint, Eugene: Wipf and Stock Publishers, 2000), 107.

metallic cursive stenciled in fluffy black hair (fig. 5). These cars are funky, no doubt, but their facture takes a distance from the pimped-out rides that populate blaxploitation classics like *The Mack* or crop up in MTV tours of rap stars' cribs. Instead, these artworks function as spurs to memory for a generation of mothers, fathers, sisters and brothers who found themselves on the run from the black wreck and wondering what to do with the ashes falling on their skin.

Newkirk's art holds out a series of responses to this quandary, seizing on the centrality of imaginative self-fashioning to the historical production of black identity. In his practice, especially in the pony bead curtains for which he remains best known, the vernacular styles and materials of the post-civil rights inheritance are time and again unmoored from the figures they adorned, edited to generalities and tweaked in scale to stunning effect. *Legacy* (1999) is a case in point: in it, polyurethane afro picks, each precisely the height of the artist's body, form a circle that simultaneously reads as an outsized crown and a discomfiting enclosure (fig. 6).4 In thus riffing on the cultural nationalist hairstyling tool of choice, Newkirk puffs up, parodies and pays homage to the ambitions of black pride,

registering the limits of that ethos as well as its subsequent commodification (fig. 7).

Off of the street and into the gallery: this is a well-trodden road within the annals of modern art that handily takes us from one end of the twentieth century to the other, from Dada Duchamp to Brother Basquiat.5 Like his precursors', Newkirk's turn to everyday objects plays to the art world's predilection for urban grit as shocking museum display. But just as importantly, his choices reflect on the peculiar bond between black bodies and the other shiny things with which they have been conflated and exchanged. That storied relation, so the psychiatrists tell us, is one marked by love, loss and every kind of disaffection. According to William H. Grier and Price M. Cobbs, the authors of the 1968 classic *Black Rage*, "for black people the ability to divorce oneself emotionally from an object is necessary for survival."6 Yet in the face of dispossession and dire circumstance, colored folks go on embracing whatever objects they can, either carried on the body or serving as its stunning conveyance: Caddies and gold chains, picks and pomade, beads and basketballs, even fake floss (fig. 8). This is the stuff of selfhood and solace in the West, and on this score, it is worth

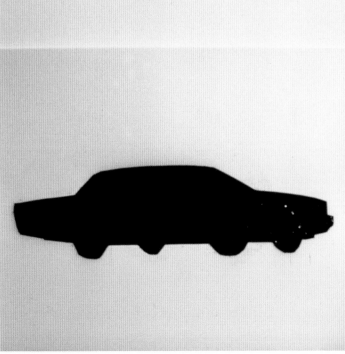

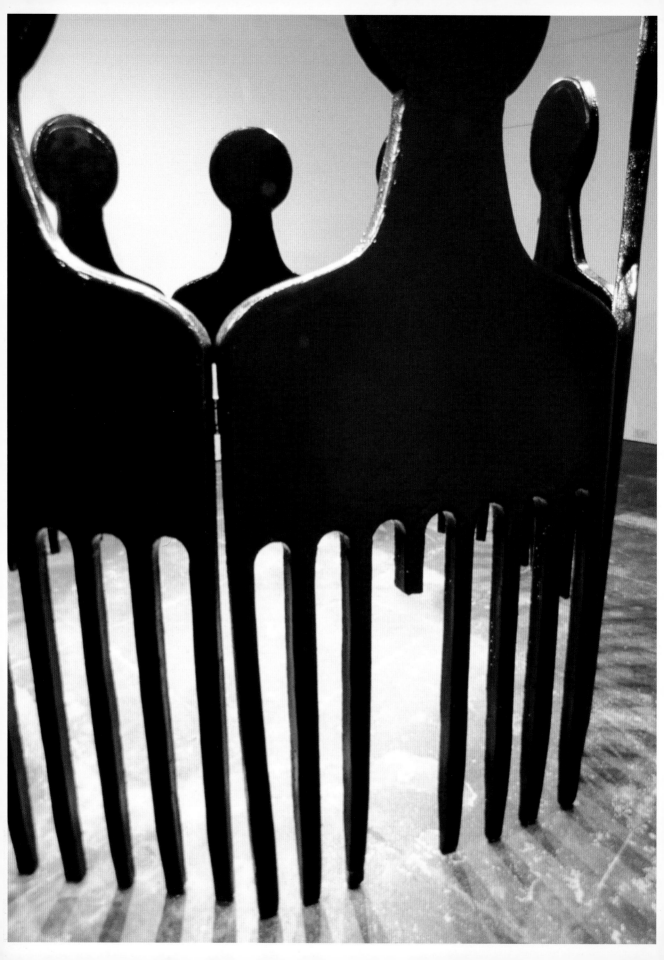

(fig. 6) • Kori Newkirk • Legacy • 1999
(fig. 7) • Kori Newkirk • Legacies • 1999

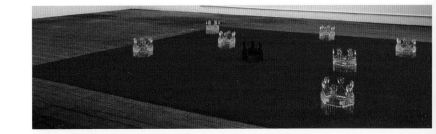

[fig. 12] • Kori Newkirk • Black Top • 2002

7 Kobena Mercer, "Black Hair/Style Politics," in *Welcome to the Jungle: New Positions in Black Cultural Studies* (New York: Routledge, 1994), 100.
8 Gina Kaufmann, "Hair Apparent," *Pitch Weekly*, May 9, 2002.
9 Newkirk as quoted in Christine Y. Kim, "Color Blind," V, March-April 2003, 142.
10 Maurice O. Wallace theorizes these determining conditions in "Spectagraphia," the first part of his book, Maurice O. Wallace, *Constructing the Black Masculine: Identity and Ideality in African-American Men's Literature and Culture, 1775-1995* (Durham: Duke University Press, 2002), 19-50.
11 Newkirk kindly pointed out each of these references to me in an email on August 30, 2007. It should also be noted that his work on the modes of violence directed at black men extends beyond the symbolic realm. I think in particular of *Swinging on the Family Tree* (1997) and *Always* (1999), which formally recalibrate lynching ropes and handguns, respectively.

recalling the words of critic Kobena Mercer, who wrote, "the question of style can be seen as a medium for expressing the aspirations of black people historically excluded from access to official social institutions of representation and legitimation in urban, industrialized societies of the capitalist First World."[7]

As Mercer intimates, this is very much a modern narrative, but while the romance is Kori's, the substance is not. The artist — himself well-represented and officially sanctioned — willingly concedes the point; while he has lived in downtown Los Angeles for over a decade and even taught at an inner-city high school, back in the day he had other questions to answer.[8] "I always knew that Black was beautiful in the 60s and powerful in the 70s, but growing up in central New York State in the 80s and 90s, I didn't know what Black was supposed to be for me."[9] In these lines, race comes across as a historically contingent signifier capable of qualifying experiences constructed at a remove from the city and in the aftermath of hails aimed at redefining African-American identity. But race in what terms? To hear Newkirk tell it, blackness is up for grabs, ready to be made up and turned out, but he is all too aware that the meaning of the black image produced by spectacle can be as constraining as it is ubiquitous.[10]

We needn't look far for proof. In 1999 the artist executed a pair of self-portraits: *Channel 9*, a photograph, and *Channel 11*, another encaustic on wood (figs. 9-10). In each instance, the face of the subject or, rather, the suspect, is distorted beyond recognition, as if to literalize and so reveal how reality television programs such as *LAPD: Life on the Beat* and *COPS* render "the black male" a dark menace who is always already culpable.[11] Taken together, Newkirk's words and works evince an attitude toward the visual predication of blackness familiar to students of contemporary art; in adding his two cents to the great catalogue of Negro life, he can afford to skip the soliloquies and the suffering, the triumph and the tragedy, to head straight for an ironic inversion of those mythical attributes figured as endemic to the black male body, particularly his own.

For an artist who came of age in the era of Air Jordan, what better location to enact such inversion than the basketball court?[12] If you've met Kori, sidled up to *Legacy*, or seen him

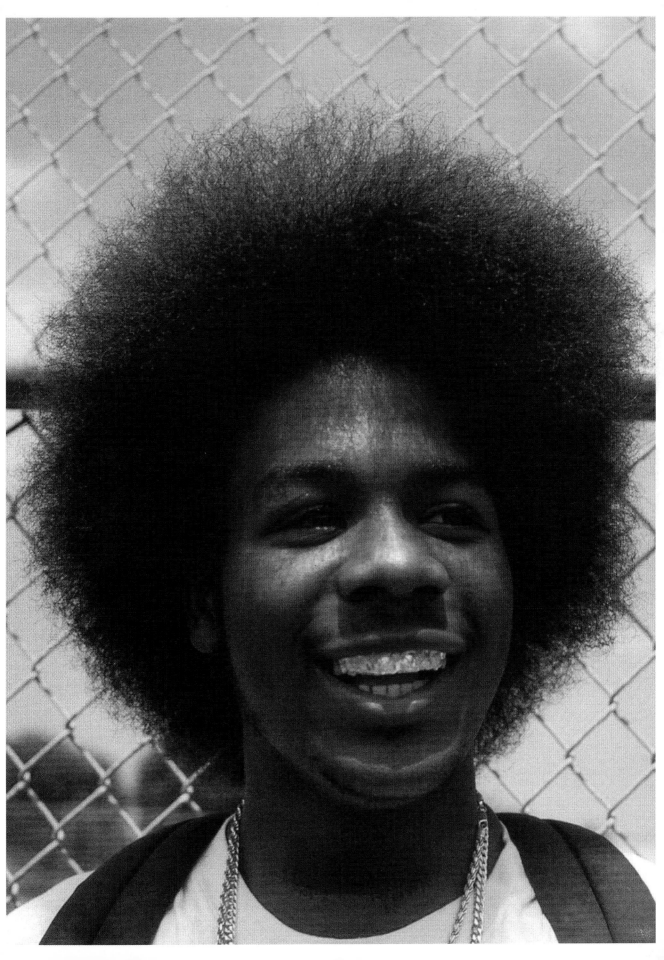

12 Indeed, several black male practitioners roughly of Newkirk's generation, such as Hank Willis Thomas and Dave McKenzie, have made use of Michael Jordan as icon in their art. See Hank Willis Thomas, "Swoosh: Looking Black at Nike, Moses, and Jordan in the '80s," (master's thesis, California College of the Arts, 2004); and Glenn Ligon, "Dave McKenzie," *Artforum*, September 2005, 291.
13 See Newkirk's comments in Rujeko Hockley, "Kori Newkirk," *Studio*, Fall-Winter 2006-07, 25.
14 A passing reference to *The Rage of a Privileged Class*, which attempts to explore the "excruciating pain" of America's successful black middle class. Ellis Cose, *The Rage of a Privileged Class* (New York: HarperCollins Publishers, 1993), 1.
15 I tip my hat here to Glenn Ligon, "Black Light: David Hammons and the Poetics of Emptiness," *Artforum*, September 2004, 242-49, particularly the opening gambit in which the artist describes his relationship to that "Crazy Nigger" his uncle Tossy, to begin charting the discursive and affective space occupied by several contemporary African-American artists.
16 Curator Elizabeth A. Brown makes an analogous point in Elizabeth A. Brown, *Kori Newkirk: To See It All* (exhibition brochure) (Seattle: Henry Art Gallery, 2003).

17 José Esteban Muñoz, *Disidentifications: Queers of Color and the Performance of Politics* (Minneapolis: University of Minnesota Press, 1999), 31. Not only does Muñoz's book brilliantly theorize disidentification, it also examines a family of cultural practitioners whose work might be usefully compared with Newkirk's. Of particular interest are the essays treating Jean-Michel Basquiat, Isaac Julien, Vaginal Creme Davis and "the *reconstructed* identity politics" of Felix Gonzalez-Torres (Muñoz, 164).
18 Newkirk makes this claim in Peter Goddard, "Beads Speak of Suburban Dreams and Delusions," *Toronto Star*, January 29, 2005.
19 Muñoz, 12.
20 Here I redact Newkirk's comments from his conversation with me on April 20, 2007. In my use of the term "worldmaking," I again follow Muñoz's lead. (Muñoz, 195-200).
21 My language here is borrowed from Judith Butler, "Critically Queer," in *Bodies That Matter: On the Discursive Limits of Sex* (New York: Routledge, 1993), 229, 231.

in *Patter* (2001), you know he's about 6 feet 2: not Shaquille O'Neal-tall, but tall enough and lithe enough and black enough to be pegged as a baller, despite the fact that his sport of choice growing up was competitive figure skating (fig. 11).[13] Even now, the game clings to him like so much other residue, material that he recoups in works such as *Black Top* (2002), *Assumption-Full Court* (2002) and *Pool* (2001), a trio as consistent in their shared target as they are promiscuous in their tactics. In *Black Top*, the artist's shorn hair, patiently glued to paper, diagrams a court; the body's cast-offs construct an image of the place from which it is absent (fig. 12). Inkjet prints of basketballs are linked by chains of acrylic paint in *Assumption-Full Court*, wittily replicating the structure of a DNA sequence while dispelling any assumptions about the artist's inherent athletic gifts (fig. 13). Last but not least, *Pool* presents the objects of the game sliced into sections like so many oranges, then placed in a neat circular arrangement, a gesture that is almost as precious as it is aggressive (fig. 14).

Precious and aggressive. Just what kind of moves do these works make? And what really is the artist's game? Is he going "ghetto" to get over? I don't think so. The tone of Newkirk's practice hardly smacks of "the rage of a privileged class."[14] It feels, rather, like a funny kind of loving otherwise, something akin to that mixture of anxiety and admiration you might have for your "crazy" aunt who prefers her cigarettes mentholated and her pants stretchy, the sort of figure ripe for institutionalization, be it in the madhouse or the museum.[15] As in the Cadillac pieces, in his plays on basketball, Newkirk stages his own alienation from an archetypal site associated with African-American men, registering his interest in and distance from those modes of representation — family trees, blueprints and genetic codes — that would presume to locate his position in the world before he has arrived within it.[16]

In recasting racial fictions in styles more befitting his taste, he engages in what cultural theorist José Muñoz calls "the process of disidentification," which ". . . scrambles and reconstructs the encoded message of a cultural text in a fashion that both exposes the encoded message's universalizing and exclusionary machinations and recruits its workings to account for, include, and empower minority identities and identifications. Thus, disidentification is a step further than cracking open the code

of the majority; it proceeds to use this code as raw material for representing a disempowered politics or positionality that has been rendered unthinkable by the dominant culture."[17]

Pool, I would argue, offers one possible outcome of this process. In cutting and then dispersing basketballs, Newkirk disrupts one metric by which the black male is measured, and with his punning title begins to suggest other arenas in which that subject might be imagined, even if still phantasmatically connected to the court. Although he hates basketball, Kori can't let it go.[18] Or, as Muñoz puts it in psychoanalytic terms, "like a melancholic subject holding on to a lost object, a disidentifying subject works to hold on to this object and invest it with new life."[19] For Newkirk, as for so many queers of color who have felt themselves alien and invisible within the American cultural landscape, the figuration of unthinkable positions through familiar means becomes not only a mode of survival, but a method of worldmaking.[20]

Although he rarely points up his sexuality in his practice, several of Newkirk's basketball works—in particular hoop pieces such as *Net Gains* (2000), *Huddle* (2002) and *Suggett* (2002) — are fabulously queer, which is to say that they deform and misappropriate the game, "spawning a different order of values"[21] and begging the question of gay visibility within the overdetermined arena of black male athleticism. In *Closely Guarded* (2001), for example, a white cotton net has been traded for long strands of false hair covered with silver beads, the whole ensemble tapering to a narrow opening before cascading to the floor (fig. 15). The artist has siphoned energy from the court in favor of the gallery's hieratic cool, displacing visual attention from the movement of sweating black bodies to static shimmering baskets and imbuing a tired "masculine" figure with freshly "feminized" meaning. You might call it "subversive;" I would say it's fierce.

Transformed from a functional to a queered object, *Closely Guarded* signifies wildly, calling up hairnets and chain mail and jockstraps and jellyfish of the most glamorous and unnatural orders. But this work and its fellows refer most pointedly, I think, to David Hammons's over-the-top basketball goals, produced in and around New York in the mid-1980s. Hyperbolically tall, decorously patterned with bottle caps and razor-sharp in their critique of the game's viability as a way out of black dereliction,

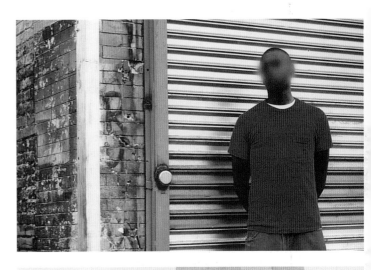

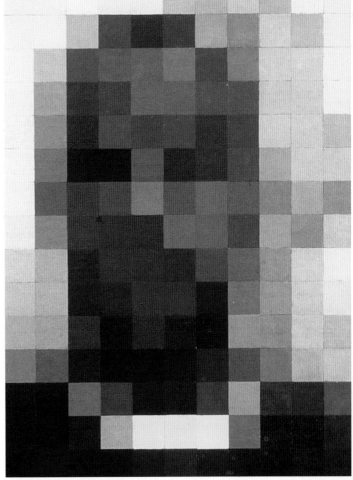

[fig. 11] • Kori Newkirk • Patter (detail) • 2001 064

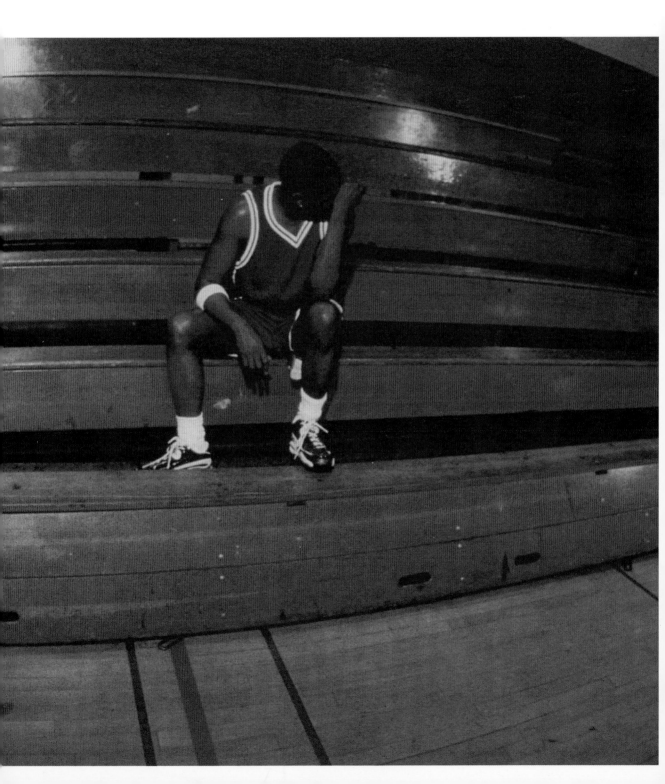

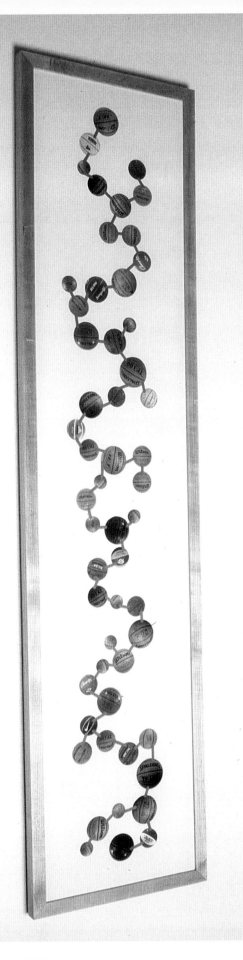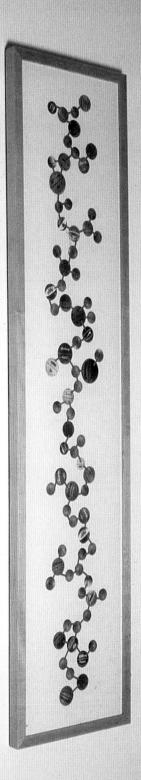

[fig. 14] • Kori Newkirk • Pool • 2001
[fig. 15] • Kori Newkirk • Closely Guarded • 2000-2001

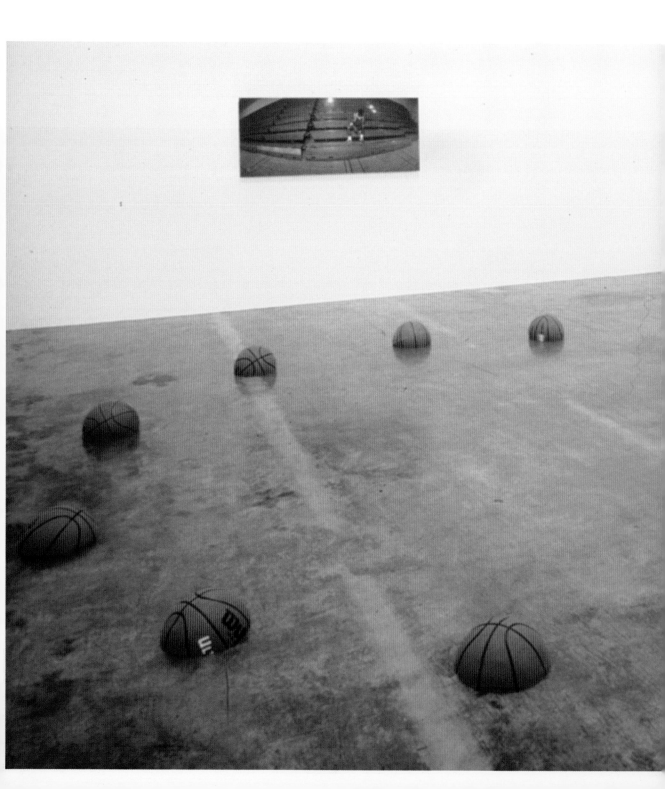

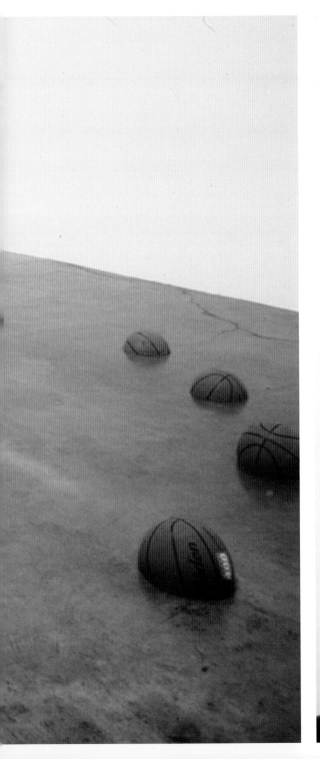
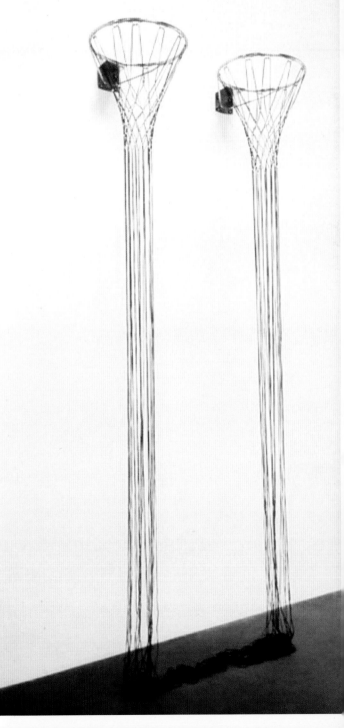

(fig. 16) • Kori Newkirk • Jubilee (detail) • 1999

IMAGE INFORMATION / LEFT TO RIGHT

[fig. 27] • Kori Newkirk • Solon 6:12 [detail] • 2000
[fig. 18] • Kori Newkirk • Huff • 2001
Kori Newkirk • Cry Baby [detail] • 2001

072

22 For one take on Newkirk's debt to Hammons from which I have profited, see Christopher Knight, "Ideas Are Being Bounced Around in These Basketball Puns," *Los Angeles Times*, June 22, 2001. For incisive readings of the older artist's practice, see *David Hammons: Rousing the Rubble* [exhibition catalogue] [Cambridge: The MIT Press and New York: The Institute for Contemporary Art, P.S.1, 1991].
23 I outline Ligon's relationship to the specular articulation of blackness in Huey Copeland, "Untitled [Jackpot]," in *Glenn Ligon: Some Changes* [exhibition catalogue] [Toronto: Power Plant, 2005], 119–32. That argument is fleshed out in my chapter on the artist in Huey Copeland, "Bound to Appear: Figures of Slavery in the Art of Glenn Ligon, Lorna Simpson, and Fred Wilson," [PhD diss., University of California, Berkeley, 2006].

24 Frantz Fanon, "The Fact of Blackness," in *Black Skin, White Masks*, trans. Charles Lam Markmann [New York: Grove Press, 1967], 109.
25 Newkirk's African-American artistic "relations"—those practitioners invested in radically deconstructive approaches to the figuration of blackness – might also be said to include Leonardo Drew, Ellen Gallagher, Lorna Simpson and, of course, Mark Bradford, the Los Angeles-based artist whose well-documented interest in black hair and basketball as materials have often earned him comparisons to Newkirk. Here, however, I want both to clarify and muddy the lines of descent linking three "generations" of black male artists. For an analogous effort that examines Hammons, Gallagher and Newkirk, see Ines Gebetsroither, "Moves, Cracks, Hair," *Spike*, Summer 2006, 60–68.
26 Thelma Golden, "Introduction: Post ...," in *Freestyle* [exhibition catalogue] [New York: The Studio Museum in Harlem, 2001], 14.

these works set the standard that Newkirk looks toward.[22] Indeed, his affinity with Hammons and a whole host of more established black male practitioners is unmistakable, particularly in the case of Glenn Ligon, whose art plumbs the visual construction of black masculinity through reflexive iterations of a "self" that differentially opens onto the social and spectatorial fields.[23]

All three of these brothers know how to make a picture. They do so by letting their materials — whether paint, body or wax — accede both to their internal logic and to the weight of history, an economy of means that imbricates "black culture" and conceptual stratagem. Note how Ligon traced Ralph Ellison's words onto panels of bodily dimensions. Consider one of the prints in which Hammons forced his face into the contours of a spade to enact physically the constriction of racial stereotypes. Now picture these works alongside *Channel 11*. Together they comprise a suite of improvisations on the facts of blackness so famously noted by philosopher Frantz Fanon more than fifty years ago: "I came into the world imbued with the will to find a meaning in things, my spirit filled with the desire to attain to the source of the world, and then I found that I was an object in

the midst of other objects."[24] Like their not-so-distant relation, these artists play on the dissonance engendered when black men literally or metaphorically run up against the sites, tropes and visual techniques that give racial phantasms their grounding in the real.[25]

But how do we get at the historical specificity of Newkirk's tactics? What does his art suggest about how racialized reference operates now? Is it enough to call his work "post-black" and leave it at that? Coined by Ligon in conjunction with curator Thelma Golden, that term was meant to encapsulate the outlook of artists, such as Newkirk, Dave McKenzie and Mark Bradford, who were included in the 2001 Studio Museum exhibition *Freestyle* and "who were adamant about not being labeled as 'black' artists, though their work was steeped, in fact deeply interested, in redefining complex notions of blackness."[26] The attitude described here certainly speaks to Kori's statements in interviews and articles, and it also offers an opening onto his approach to the disarticulation of race.

Artist and critic Kianga Ford takes us one step further. To her mind, what is new about Newkirk's practice and that of his

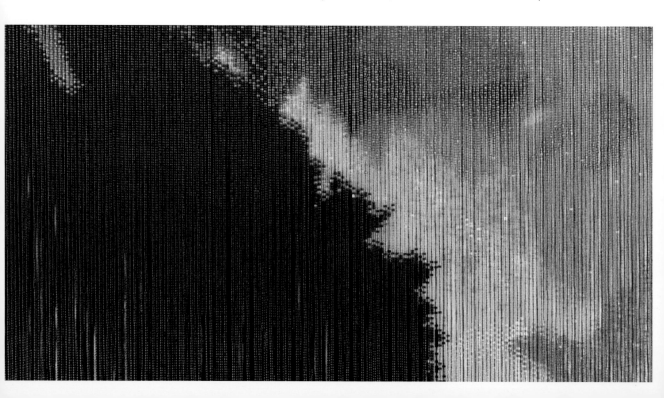

27 Kianga Ford, "Matters of Race: Medium, Material, and Post-Identity," (paper, Ninety-Second Annual Conference of the College Art Association, Seattle, February 19, 2004).
28 Newkirk, quoted in an insightful article by Malik Gaines, which, along with Ford's essay, has directed my thinking in this paragraph. See Malik Gaines, "Young, Gifted and Confused: Four Emerging Artists Talk Politics," X-Tra, Fall 1998, 13-14. In that article, Newkirk underlines the importance of the "politicized" art of the early 1990s for his own practice, both in terms of what he might freshly articulate and what could possibly be heard in a post-identarian art world. On this score, also see Bruce Hainley, "Kori Newkirk," Artforum, February 2000, 124.

29 Newkirk described his image choices in an email to me on August 22, 2007. On the significance of the Williams sisters for his art, see Peter Goddard, "Beads Speak of Suburban Dreams and Delusions," Toronto Star, January 29, 2005; and Rachel Teagle, Cerca Series: Kori Newkirk (exhibition brochure) (San Diego: Museum of Contemporary Art, 2005).
30 Curator Olukemi Ilesanmi points to Jubilee's kinship "with the color-fielded world of Clyfford Still and Barnett Newman." See Olukemi Ilesanmi, "Ease on Down Newkirk Road," in Kori Newkirk (exhibition brochure) (Overland Park: Johnson County Community College Gallery of Art, 2002).
31 Newkirk's comments on his projective relationship to the sites his pictures can be found in Olukemi Ilesanmi, "Ease on Down Newkirk Road," in Kori Newkirk (exhibition brochure) (Overland Park: Johnson County Community College Gallery of Art, 2002).

peers is that while previous strands of artistic production also emphasize the material signifiers associated with blackness, in the work of the younger set, those signifiers are no longer pressed first and foremost into deconstructive service, but are primarily accumulated for pictorial gain without ever positing a racialized subject. Of course, such a distinction does not cut cleanly along temporal or generational lines, but it does highlight a posture toward blackness, which while evident in past artistic discourses, comes hurtling to the fore in the present.[27] As my father might say, it's all about the contours; as Kori himself will tell you, "[t]he first thing is the aesthetics," and as his work makes manifest, that aesthetic entails neither a repudiation of identity politics nor a simple return to earlier canons of beauty.[28] I would contend, rather, that Newkirk doubly disidentifies — on one hand from the conventions of Modernist painting and on the other from the constitutive vectors of black visibility — to string together pictures of the world as if remade from memory.

Jubilee (1999), the artist's very first curtain, is one such picture (fig. 16). A brilliantly hued 8-foot square, the work is composed of braided strands of synthetic hair threaded through plastic pony beads and hung from an aluminum frame. The media attention focused on tennis stars Venus and Serena Williams's beaded braids inspired Newkirk's choice of materials, and a mélange of memories and photographs, including ones of Los Angeles aflame during the 1992 uprising, provided the basis of an image.[29] Like the Color Field paintings to which it bears more than a passing resemblance, this work depicts no bodies — no crouching Rodney King, no angry rioters — but its virtual abstraction is as much about optical transcendence as it is about black eschatology.[30] Among the more than sixty curtains Newkirk has executed to date, Jubilee is exceptional for its topical and identifiable referent. Yet it shares with the others a haunting figural emptiness and a "black" materiality, the better with which to undermine fixed ideas of the African-American subject's "proper" place and allow both the artist and the viewer to plot themselves imaginatively in the locations pictured, as belonging among the trees, along the skyline, in the city or in the suburbs (fig. 17-19).[31]

To many eyes, the homes nestled just over the fence in *Younger* (2004) do, in fact, appear welcoming (fig. 20). The image itself is quaint, but the interest of the work derives from its massive

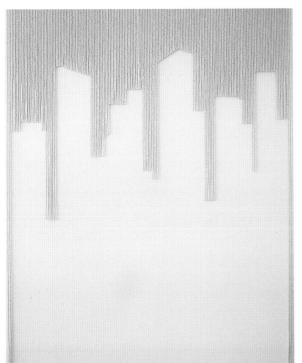

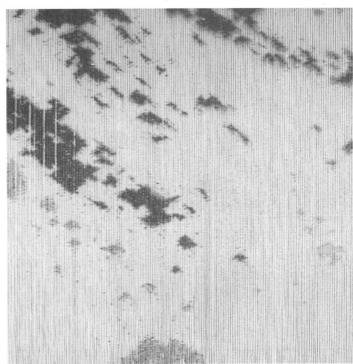

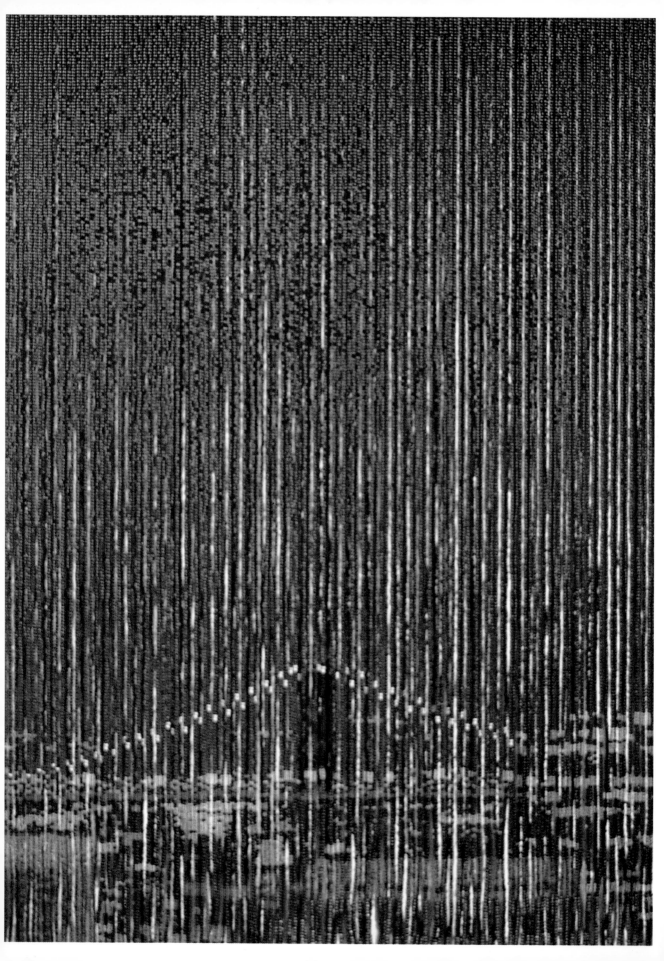

(fig. 19) • Kori Newkirk • Bam Bam • 2003

32 Lorraine Hansberry, *A Raisin in the Sun* (New York: Samuel French, Inc., 1959).
33 Newkirk quoted in Peter Goddard, "Beads Speak of Suburban Dreams and Delusions," *Toronto Star*, January 29, 2005.
34 Newkirk as quoted in Rujeko Hockley, "Kori Newkirk," *Studio*, Fall-Winter 2006-07, 25.
35 Fanon, 109.

scale and its ability to lure us closer, not to seek out traces of the artist's hand, but to inspect more closely the curtain's pixelated facture and to assess its capacity for breath, movement and blackness. The title is key. "Younger" is the name of the working-class African-American family immortalized in Lorraine Hansberry's 1959 play *A Raisin in the Sun*. Set in a cramped apartment in Chicago's south side, the drama takes place after the death of Mr. Younger and principally revolves around the tension between his widow, Mama, and their son Walter Lee, who have conflicting ideas about what to do with the $10,000 insurance payout. Ultimately the family decides to proceed with Mama's initial dream, so despite the expense and the veiled threats, the Youngers prepare to move into white suburban Clybourne Park.[32]

For Newkirk, that neighborhood might have been his own and in conceiving the curtain he recalled Hansberry's cast: "I thought of myself as the son in the family, or maybe the son of the son, and maybe this is the house they moved into."[33] More than a fanciful projection, the artist's account of *Younger* alters the valence of the work, uncovering the invisible presence of black subjects and the realities of segregation within a seemingly innocuous scene. For all its divergent representational modes and swings in mood and emphasis, Newkirk's practice consistently explores the coordinates of life lived black by working with and against the grain of African-American popular iconicity. "Universally," he tells us, "I am engaged with the idea of the black body, in all these different permutations and situations — and not necessarily 'the black male body,' but the idea of the body as fact, not as spectacle."[34] To this we might add, the body as produced by spectacle, caught in the grip of stereotype, moved by queer notions and awash in representations of itself: these are Newkirk's facts of blackness. Yet his Fanon is less the man who feels "sealed into [a] crushing objecthood" and more the spirit who continues to "attain to the source of the world."[35]

When I interviewed Kori in his studio several months ago, he was at work on a curtain. The beading went slowly but our conversation flowed easily, so much so that I neglected to check my parking meter. When I reached the street, it became clear that my rental car — a non-descript white bubbly thing — had been towed by the city. Kori came to my rescue and the curtain is now complete. While the events of that afternoon will doubt-less fade in time, the work still connects us, a site that opens onto recollections to which we both might lay claim. Kinship is where you find it and the art of Kori Newkirk shows us how we might remake our relations in the world one object at a time.

(fig. 20) • Kori Newkirk • Younger • 2004

FOOTNOTES

1 Unless otherwise noted, all Newkirk quotes come from Kori Newkirk, in discussion with the author, March-April 2007.
2 Rujeko Hockley, "Kori Newkirk," *Studio*, Fall-Winter 2006-07, 25.

How does one imagine the black body, specifically the unclothed black male body, in art? I posed that question to Conceptual artist Kori Newkirk one afternoon in April 2007, and he considered answering it in multiple ways, from generalizing the question with collective ideas about the black male body to individualizing it with his own body. In his work, he says, he frames his ideas about that subject by documenting his own body through time. By constructing a narrative in still and moving images, Newkirk uses the genre of self-portraiture to document and "imagine" the unclothed body. He feels that the unclothed body is central to his work because "clothes mark the body and lock it into time."[1] In a recent interview in the pages of *Studio*, he said:

Universally, I am engaged with the idea of the black body, in all these different permutations and situations — and not necessarily the "black male body," but the idea of the body as fact, not as spectacle …. So my work, in all its various manifestations, is maybe linked by this desire to talk about the black body in a way that hasn't been addressed, in places that haven't been addressed. It's a direct response to the urbanization of the black body, the reduction of the spaces where black bodies are seen to exist. It's a way to see myself in the art world and the larger world.[2]

This ten-year retrospective is both reflexive and illustrative, humorous and ironic, sensual and spellbinding. Indeed, it delineates and obstructs the notion of twentieth-century abstraction. Newkirk expands upon a historical and cultural chronology that is full of both facts and lore. In works such as *Testing the Wind* (2004), Newkirk offers the viewer the notion of conjuring. These large-scale color photographs come complete with sensory experiences that embody taste, touch and sound. There are elements in this composition that evoke the genre of portraiture. However, the fragmented images that make up the photograph evoke a sense of mystery or secrecy. Notably, Lorna Simpson's, *Hypothetical?* (1992) bears a strong resemblance to Newkirk's work in the framing of lips. The shape of the lips are the central focus, and the placement of the images offers the viewer an opportunity to free associate with *Testing the Wind*. Similarities between the works of Newkirk and Simpson include performative aspects and the unlocking of mysteries. Art historian and curator Kellie Jones writes of Simpson, "She is fascinated by methods of performance: how actors build characters, their ability to

KORI NEWKIRK AN IMPACT 1997–2007!

DEBORAH WILLIS

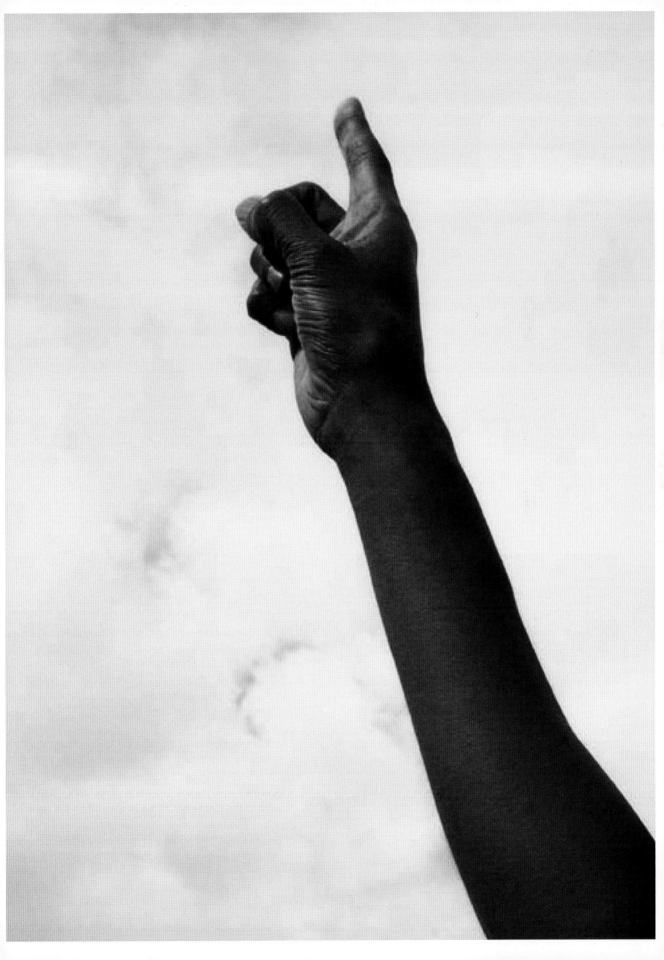

3 Kellie Jones, Thelma Golden and Chrissie Iles, *Lorna Simpson* (London: Phiadon, 2002), 83.
4 Romare Bearden, "The Negro Artist and Modern Art," *Opportunity: Journal of Negro Life* (December 12, 1934): 372.

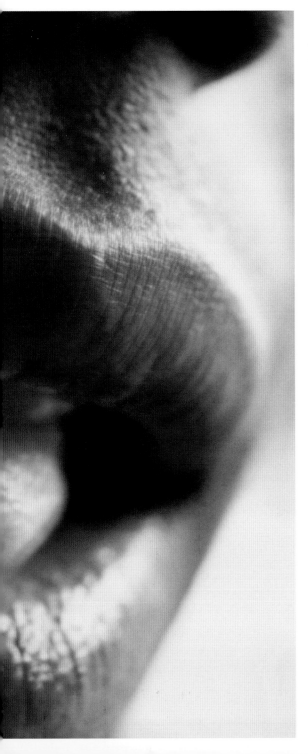

switch between personae from moment to moment."3 Newkirk is both the actor and director in *Testing the Wind*. We are confronted with both the beauty of his lips and the possibilities of fate. How does one "test the wind"? Newkirk's outstretched arm and finger gesture toward the clouds, inviting the viewer to join him in this imaginary journey of chance. In *Par* (2004), a figure lies on green grass, wearing a white shirt and blue-striped tie. The face is obscured, as if he is covering his eyes from the sun or deep in thought. Newkirk's *Par* can be seen through the worlds of golf and high finance. The meaning of "par" ranges from a number of strokes in golf to terms that can be used to describe his style of dress — successful, cool, perfect: up to par. But his gesture may allude to a question: Is he up to par? Over the past ten years, I have witnessed Newkirk's work evolve from works that critique American culture to works that expand on that critique and move from humor to pathos. His work is both smart and witty. The challenge for the viewer is to move along with him as he explores diverse ways in which to create his art. His use of photography is not restricted to the notion of "fine art" photography. To be sure, he is not a conventional photographer. Rather, he is an artist that sees photography as a tool to express his ideas, in the same way he uses beads from hair salons to visualize a painting. I suggest that he uses the camera in the same way that Romare Bearden used collage. In my view, Newkirk's visual messages are varied.

Inspired by photography, painting, video, film noir, pop culture and political art, Newkirk is secure in his own artistic vision. As Bearden asserts, "Practically all the great artists have accepted the influence of others. But the difference lies in the fact that the artist with vision sees his material, chooses, changes, and by integrating what he has learned by his own experience, finally molds something distinctly personal."4 This is evidenced in Newkirk's vast and diverse oeuvre, into which he has integrated childhood memories, observations from life and participation in contemporary art practices. Land and landscapes are clearly measured terrain in his creative process in both his video work and photographs. This is the nature of Newkirk's poetic images. He is often the observer and the participant. What he observes at the moment dictates his choice of camera, from a large format, to a medium format, to a fast point-and-shoot, to a handheld digital or a plastic Holga — in his words, "whatever is available."

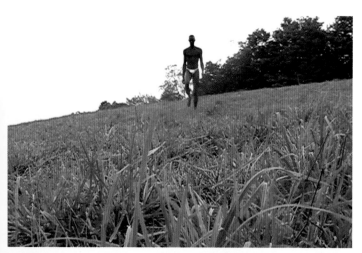

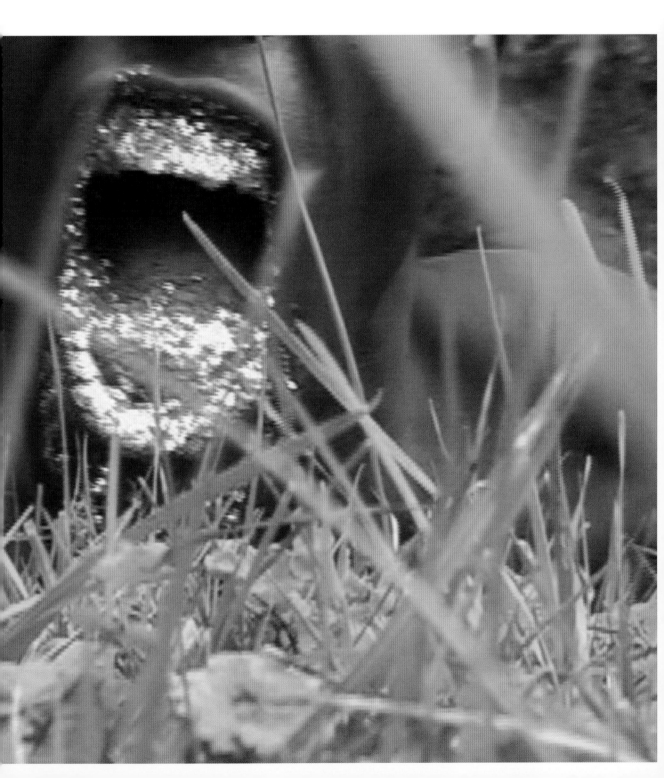

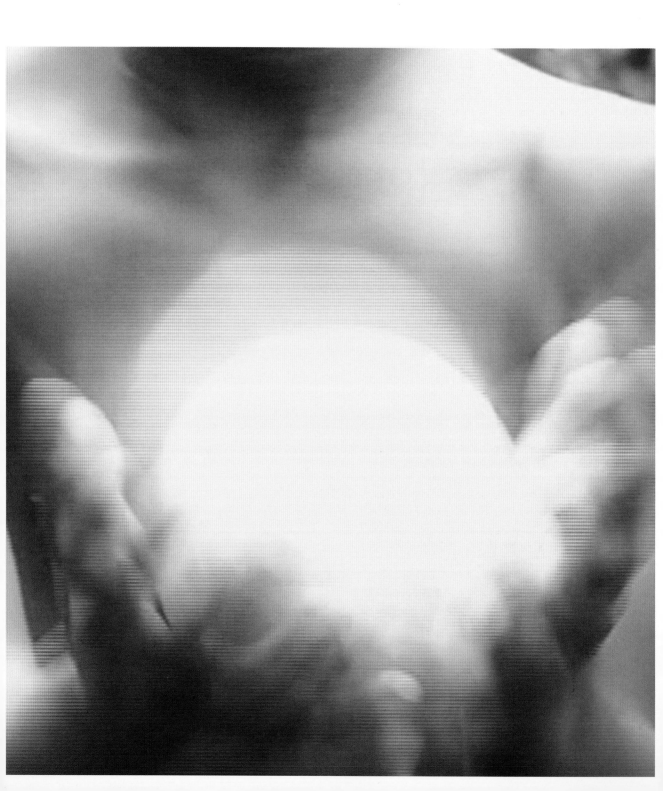

Newkirk grew up in a house surrounded by photographs. His father was a serious amateur interested in documentary photography and used to tell "tales" about how he and another photographer, strapped back-to-back, took photographs during the summer riots of the 1960s — "where one would actually watch each other's back so they could shoot burned-out stores and buildings." The surviving photographs and stories helped to shape Newkirk's understanding of the immediacy of photography. Other influences include Gordon Parks's iconic images, such as Ella Watson posed in front of the American flag with mop and broom in *American Gothic* (1942), and Pat Ward Williams's use of appropriation and archival investigation, especially in the oversized, confrontational image exhibited in the 1993 Whitney Biennial, *What You Lookin' At?* (1992). Newkirk studied with Williams at University of California at Irvine in the 1990s. Other contemporary influences include Carrie Mae Weems's "Kitchen Table Series" (1990). That series "requires a lot of work. She's not giving it all to us. The viewer must be willing to work to understand what is going on in the work," Newkirk says. "That is what I want from my viewers and my images." And the photographs of both Glenn Ligon and Lyle Ashton Harris helped shape his reading of the black male body.

Arguably the original Harlem portrait photographer, James VanDerZee created mortuary portraits that also fascinated Newkirk, who finds the notion of documenting memorials in photographs both beautiful and awkward. The idea of funeral photographs resonate for him. The presence and absence of the black male body is a theme throughout his work. The tall, partially nude figure in *Bixel* (2005) is both disarming and beguiling. The dreamlike, out-of-focus figure stands in his underwear in an open field. The rich green of the grass enhances the mystery of the image. Where is he coming from? Where is he headed? *Bixel* also includes video stills, which have a ghostlike quality reminiscent of VanDerZee's mortuary portraits, of a headless body peeping through blades of grass.

It is clear when viewing this body of work that Newkirk is influenced by the narrative in photography — image with text. He often enhances a visual plane by using strands of plastic beads to create an image. Within the hanging beads, he frames streetscapes and houses. The beaded works become dialogues between the visual record and the metaphoric experience of community. He re-images photographs onto strands of beads to create an art object—meditative and idealized studies. His understanding of language is provocative and revealing of his sense of humor. By writing with neon, he illuminates words and phrases stored in our collective memories. We recall them from our grandparents and parents, as well as from "street culture." He jokingly describes himself as a "sponge," noting that he "reads lot of books, speaks often about his own identity and reflects on how the individual erases and obscures." Newkirk says that the figures in the works "are not necessarily me" and "not the individualized black maleness" — he is representing not one but "every-one."

Kori Newkirk • 1up • 2005
Kori Newkirk • 2up • 2005
Kori Newkirk • 3up • 2005

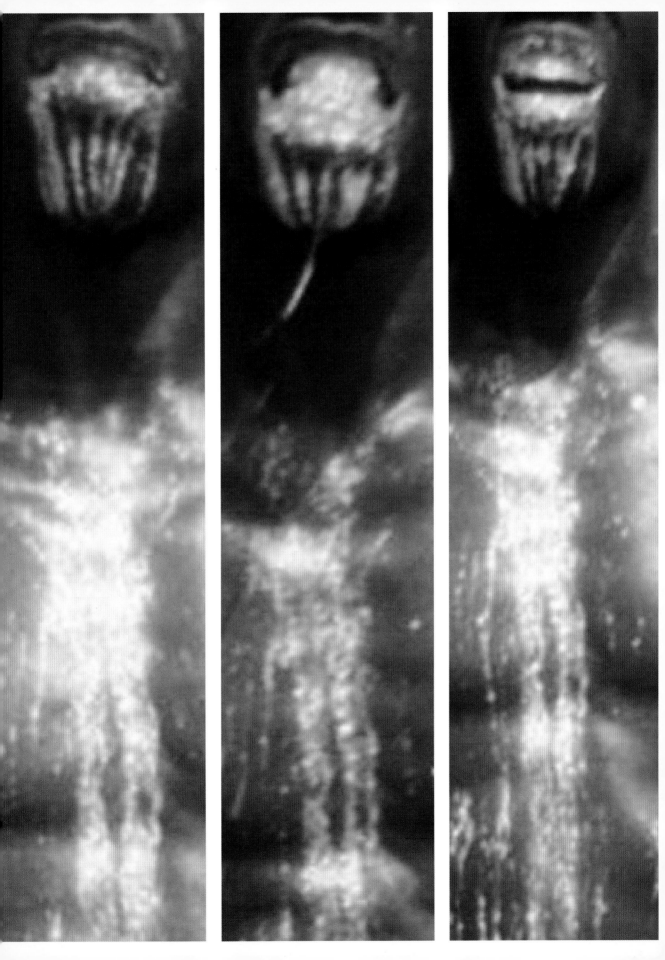

EXQUISITE, ELEGANT AND ESTRANGED

DOMINIC MOLON

I AM LOST TO THE WO
WITH WHICH I USED
SO MUCH TIME,
IT HAS HEARD NOTHIN
FOR SO LONG
THAT IT MAY VERY WE
THAT I AM DEAD!

LD
D WASTE

G FROM ME

LL BELIEVE

IT IS OF NO CONSEQU
WHETHER IT THINKS
I CANNOT DENY IT,
FOR I REALLY AM DEA

I AM DEAD TO THE WO
AND I REST IN A QUIET
I LIVE ALONE IN MY HE
IN MY LOVE AND IN MY

— FRIEDRICH RÜCKER
"ICH BIN DER WELT
ABHANDEN GEKOMME

NCE TO ME

ME DEAD;

TO THE WORLD

RLD'S TUMUL

REALM!

VEN,

SONG!

N"

1 1

1 Allegra Chamber Music, "Gustav Mahler 1860-1911," Allegra Chamber Music, http://www.allegra-chambermusic.com/notes.html (accessed September 4, 2007).

In the last scene of Jim Jarmusch's 2003 film *Coffee and Cigarettes*, aging Warhol superstar Taylor Mead (simultaneously playing himself and a fictional maintenance man on break) asks his similarly aged counterpart whether he has ever heard Gustav Mahler's song "Ich bin der Welt abhanden gekommen." Mead begins to rhapsodize world-wearily about the song's sublime beauty as it softly and strangely plays in the imaginary break room they occupy, and comments on how he too feels dead and removed from the world. It's an achingly poignant scene, one that draws on the past (Mahler's song was written in 1901-02) while capturing an utterly contemporary sense of malaise and alienation. Kori Newkirk's recent sculptural and photographic work offers a similarly existential sentiment of disconnectedness, though in a more oblique yet obviously physically present manner. This sense of unease and discontent is multifaceted, and embodies a general weltschmerz evident in the work of many of his peers, while reflecting the Artist's perpetual role a social outsider and suggesting, if only tangentially at times, an acutely felt estrangement as an African-American artist. This is not to say that Newkirk's work luxuriates in an indulgent melancholia, for his objects and images possess an exquisitely and immediately visual and tactile appeal, and rigorously and actively engage the viewer in dynamic spatial terms. It is this tension between his work's evocation of- longing and despair and its aesthetically inviting qualities that make it so profoundly affecting, compelling and effective.

Newkirk occupies an intriguing place among similarly emergent artists of his generation, having distinguished himself with work that reconsiders Conceptual and post-Conceptual art practices from an intensely personal and emotional perspective. He was initially recognized as one of a number of young African-American artists working in a manner dubbed "post-black," in the sense that his work and the work of others, including Julie Mehretu, Adam Pendleton and Eric Wesley, moved beyond surface issues of race to explore more generally contemporary content or artistic-process-oriented issues. This position, while liberating in certain respects, has led these artists into a complicated area of aesthetic identity politics in which aspects of race are always already implied or inevitably read into their work, no matter how insistently it departs from the subject. This condition of "placelessness" within the current art world

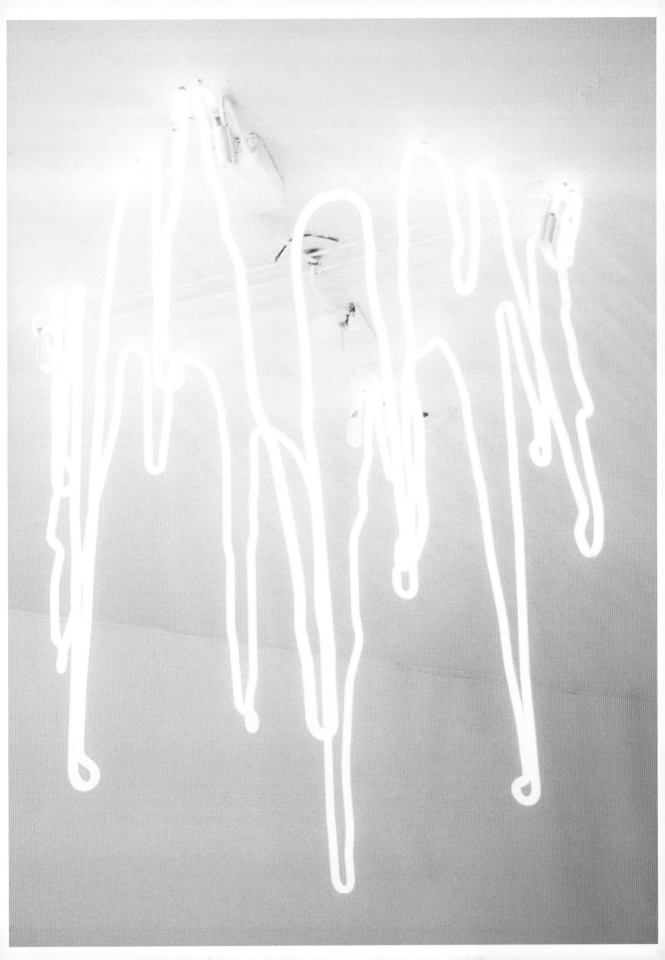

thus offers greater possibilities for individual recognition while making the critical reception of the work that much more challenging and difficult, further underscoring the sense of estrangement implicit in Newkirk's work.

This state of displacement is evident in *Helix* (2006), a sculpture of a fire escape executed in clear plexiglass and decontextualized from its expected setting of the front or back of an urban building by being suspended within the space of a gallery. The work is an example of how Newkirk reconfigures inanimate objects to signify more "human" states of mind and being. The fire escape is necessarily a sturdy and formidable structure given its practical, life-saving purpose. It is also associated with such disparate cultural phenomena as cinematic chase scenes and its "urban romantic" function as a site for contemplation and reflection that provides a way to see and be part of the "world" while maintaining a conscious distance from it. Newkirk's version seems almost ethereally weightless, hovering improbably in midair and still offering the structural properties of the object — its diagonally unfolding series of stairs and landings — if not the material stability it demands. Marooned in the middle of the gallery space, rendered functionally neuter and separated from its host building, *Helix* poignantly, if abstractly, captures the irony of urban loneliness — how one can feel so isolated and alone within the active and densely populated environment of the American city.

A no less theatrical demonstration of Newkirk's exploration of disconnectedness from the world is effected by an installation of a group of works, made in 2002 and 2003 and incorporating sculptures and photographs, that combines such wildly distinct phenomena as icicles, snow ... and sharks. One large fiberglass shark (*Win Slow* [2003]), to be precise, is set adrift in a snowy realm (a floor covered in plastic shavings) that also features an encaustic wall inlay of sharks forming a snowflake pattern (*Tully* [2003]) and snowflakes and icicles rendered in neon (*Belvue Gardens* [2003] and *Maybury* [2003]). Also featured in the installation is a hauntingly blurred image (*Haywood* [2002-03]) of a black man (the artist) nude in front of a snow-covered forest landscape. This improbable pairing of tropical and arctic phenomena shares an immediate association with the potential for harm or danger — one more immediate and the other based on extended exposure — and for an aesthetic

Kori Newkirk • Win Slow • 2003
Kori Newkirk • Haywood • 2002

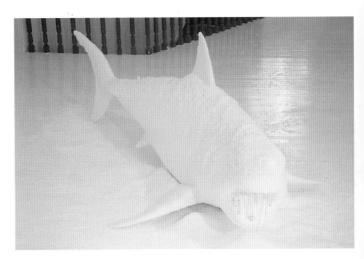

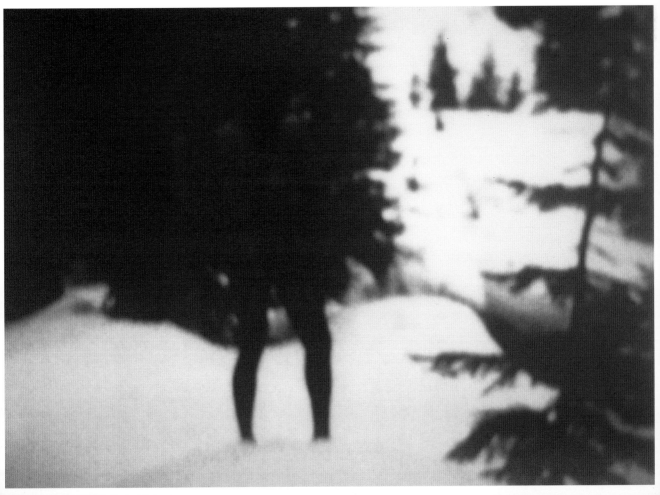

2 Kori Newkirk, "Kori Newkirk," in *The Uncertain States of America: American Art in the 3rd Millennium*, eds. Daniel Birnbaum, Gunnar B. Kvaran and Hans-Ulrich Obrist (Oslo: The Astrup Fearnley Museum of Modern Art, 2005), 84.

appreciation of their more "sublime" qualities. Newkirk taps into the romantic sensibility associated with early nineteenth-century painters, poets and musicians that revolved around fascination with forces of nature that were both tantalizingly beautiful yet capable of harm and destruction. The figure of the shark in particular has a rich iconographic history, from John Singleton Copley's *Watson and the Shark* (1778), to perhaps its most celebrated (and notorious) presence in the 1975 Hollywood blockbuster *Jaws*, to Damien Hirst's signature sculp-ture *The Physical Impossibility of Death in the Mind of Someone Living* (1991) in which a 14-foot tiger shark is encased in a formaldehyde-filled vitrine. Newkirk's shark possesses none of the malevolent threat of the fish in the painting or the film, nor does it exude the paradoxical cross of spectacular presence and mute entropy of Hirst's. Instead, its placement on the floor and fabrication from a coldly industrial material gives it an inert pathos, making it seem all the more lost and disproportionate with its environment. A strange sympathy subsequently develops between the two glaringly isolated figures in the installation — the not-so-great white shark on the floor and the solitary black man wandering in the snowy woods.

The latter figure presides over the installation as a shadowy and mysterious presence, somehow alternately exuding, like the shark, both an ominous power and an awkward vulnerability. Deliberately out of focus, the image suggests the kind of blurriness characteristic of the furtive attempts to photograph such elusive paranormal folklore phenomena as Bigfoot (a large, primitive humanoid figure said to roam the forests of North America) or the Loch Ness Monster. This murkiness perfectly underscores the ambivalence and equivocation at the heart of Newkirk's overall installation of these various objects. A snowflake and suspended icicles rendered in neon suggest something frosty and frigid, yet their material is something hot to the touch. The artist's thoughts on the shark and the cold-weather aspects of the works signal both a deep sense of dread and a complicated sense of identification:

WEATHER,
OR IMAGINE
SHARKS —
GREAT WH
MONSTERS
BURIED AL
EATEN ALI
IN SNOW YO
MOVING OF
MUST SWIM
TWO WHITE

(SEE GRAY TEXT)

ERY MUCH REAL

O, AND

PECIFICALLY THE

E — ARE MADE INTO

OR SURVIVAL.

E IN AN AVALANCHE.

E IN THE VAST OCEAN.

U MUST KEEP

DIE, JUST AS SHARKS

TO LIVE.

THINGS CAN KILL ME.

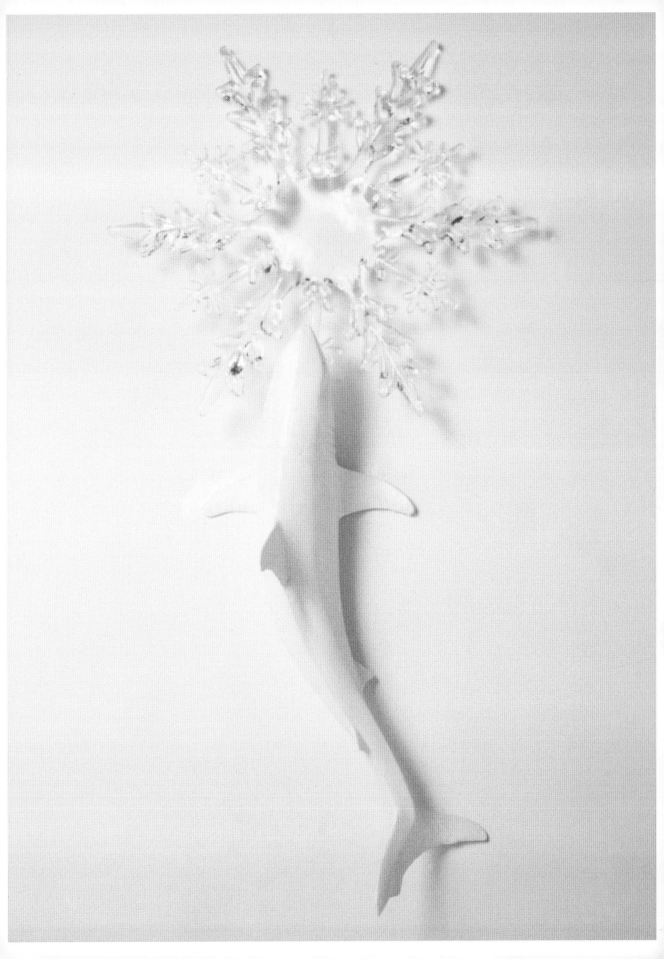

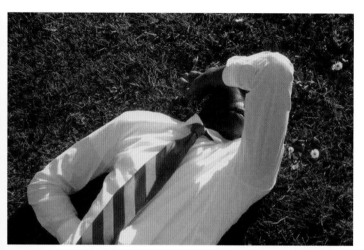

While the shark is identified as a source of potential grievous bodily harm, its own mortality is simultaneously alluded to, just as the figure alone in the woods is shown naked and therefore imminently vulnerable to frostbite. The obvious third white thing capable of killing Newkirk – people – is left unstated yet is signified perhaps by the snow and the shark. However, the sense of uncertainty informing all of the figures on view – particularly the seemingly empathic relationship of the black figure and the shark – prompts consideration of the conflicting dynamics of estrangement and identification that charge this complex grouping of works.

Three photographs from 2004, *Flank*, *Juke* and *Par*, are much more oblique in their presentations of the figure in nature. The first is, like *Haywood*, intentionally hazy and blurred, depicting a black male lying prone in the grass of what appears to be a park. Shot from ground level at something of a distance, the image has the quality of surveillance or forensic footage, as if the photographer intended to maintain a cautious distance from the subject. (Michelangelo Antonioni's classic 1966 film *Blow-Up* comes immediately to mind, as, to a lesser extent, does Alfred Hitchcock's 1955 film *The Trouble with Harry*.) The vantage point is too distant for the viewer to ascertain the status of the figure adequately, and whether he is resting, wounded, unconscious or even dead. The title of the work offers little assistance either, only indicating what is more or less legible in the photograph: that we are primarily presented with a view of the figure's right flank. Nature is indicated here not as the cause of a possibly negative effect, but as the site where something must have transpired, suggesting that the potential for violence and tragedy informs even the quietest and most bucolic situation. *Flank* also evokes the various cultural associations with "falling," from comedic pratfalls, to the more serious biblical "fall" from grace of Adam and Eve, to the various larger and smaller "falls" and collapses throughout history (not to mention the Conceptually oriented work of artists such as Bas Jan Ader, Martin Kersels and Peter Land). Open to multiple interpretations, Newkirk's photograph provides more questions than answers, prompting the viewer to determine both the circumstances by which this fallen figure came to be, as well as his ultimate fate.

Juke, also blurred, presents the same personage, seemingly in a state of repose. The angle in this picture is less "dramatic,"

thus lending the scene a warmer, almost romantic sensibility (something akin to the "soft-focus" style of 1970s porn, perhaps). Here, too, the title offers only an oblique, if completely dichotomous, explanation at best – "juke" connoting a quick motion meant to deceive or fake. This non sequitur distracts the viewer from a more facile, literal understanding of the image, prompting an appreciation of its subtler details – the slight contortion of the body, perhaps, as an indication of tension and discontent in an otherwise blissful scene.

Par, despite its greater visual clarity and presentation of a more recognizable figure, is no less inscrutable. Depicting a black man (Newkirk, once again) lying face-up in the grass and obscuring his face or shading his eyes from the glare of the sun with his left arm, this work, like *Flank*, stages an event that requires the viewer to play a more active role in "reading" the situation. Perhaps the most striking initial detail is the figure's attire (vaguely perceptible in *Flank* and *Juke*), comprising a crisp white dress shirt and a business-like striped tie, that immediately establish him in the social strata. The exact meaning and intent of his gesture is unclear, and is possibly only intended for the situation of the photograph itself by creating a parallel between the position of the arm and that of his other arm, which is bent in a similar fashion behind his back. This balance in his physical posture may be the key to still another initially perplexing title. Taken together, *Flank*, *Juke* and *Par*, are a trio of performative studies, prompting comparisons with such Conceptual photographic explorations of bodily gestures and language as Bruce Nauman's *Henry Moore Bound to Fail* (1967-70) or *Self-Portrait as a Fountain* (1966-1967/1970). Individually, however, the works present enigmatic narrative fragments, all with different levels of theatrical intensity and affect, ranging from *Flank's* dramatic vantage point and disturbing implications to *Par's* more neutral matter-of-factness. All do share the presentation of a solitary figure in nature whose relationship to his environment seems largely undetermined and unresolved – much in keeping with the undercurrent of loneliness and isolation that informs much of Newkirk's work.

The treatment of phenomena and situations relating to basketball represents Newkirk's most direct and emphatic expression of feeling socially disconnected or misunderstood. He grew up in mostly white communities, and his color and height created the immediate impression, based on racial stereotypes, that he had a "natural" aptitude for and inclination toward the sport. Newkirk, however, is neither good at nor interested in basketball, yet its role in his personal history and its continued popularity in American culture make it a compelling subject for him all the same. The photograph *Patter* (2001), for example, depicts a young black man dressed in a basketball uniform and sitting alone on empty gymnasium bleachers with his face turned aside in a gesture of fatigue or disgust. The titular reference to a sort of glib, informal form of speech suggests that the work refers to what one might imagine to have been the hurtful comments endured by Newkirk, directly or indirectly, as a result of his failure to meet expectations of basketball-playing prowess, and evokes the more general malaise of social exclusion or ostracism. *Pool* (2001) is a sculptural work comprising a circle of basketballs deflated to form small domes, making a virtue of their depleted state and further indicating the artist's complicated feelings about the sport. Another sculptural work, *Closely Guarded* (2000-01), similarly transforms an object from the context of basketball by placing two metal hoops side by side on a wall and replacing the short cloth net that typically hangs from them (intended to guide and slow the ball on its descent) with braided hair extensions. The work is both an intriguing reclamation of the objects in terms of their "blackness"– replacing the white net with black hair – and another gesture aimed to render basketball phenomena functionless (save, of course, for their purely aesthetic properties.) Finally, *Bumper* (2001) is a photographic diptych showing two basketballs placed on courts – one at the "top of the key" (the area behind the free throw line but inside or near the free throw circle) and one slightly closer to the free throw line – seemingly and somewhat sadly functioning as human surrogates. The pairing seems at first quizzical, as both are identical images, yet closer and more focused perception reveals a clever formal "game" in which the arc of the half-court circle in one picture is picked up by the three-point line in the other picture. As with his other basketball-related works, Newkirk forces an alienating game from his youth to serve his own aesthetic ends as a mature artist, negatively touching upon his personal and emotional relationship to the game while creating a more "positive" exploration of abstract visual structures and dynamics.

Newkirk's signature works are the curtains that he makes from

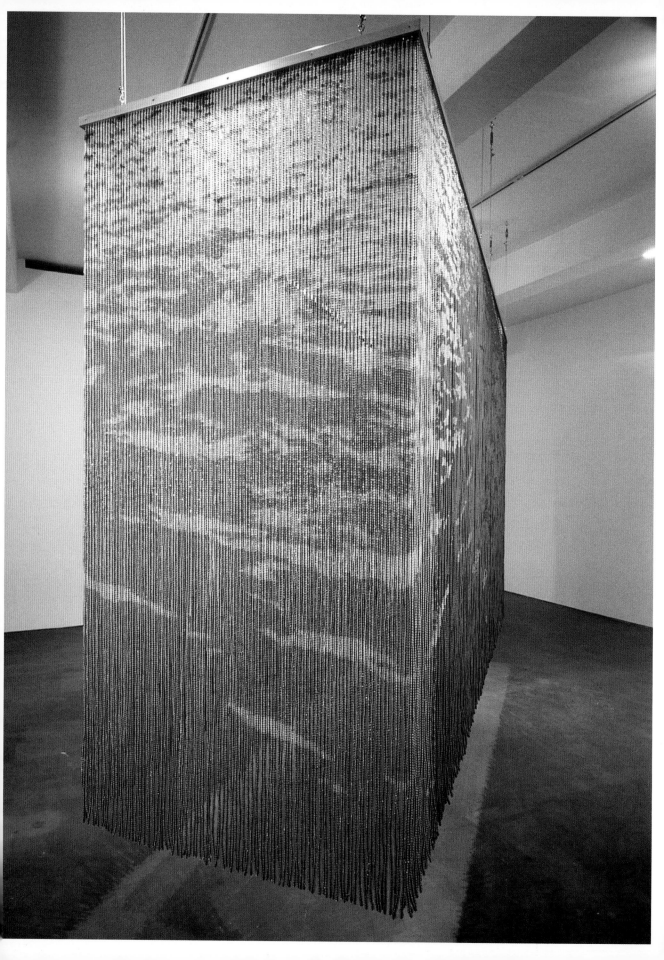

pony beads and braided hair to form either abstract shapes, silhouettes of cityscapes or images of suburban or rural environments. Successful not only in creating a pictorial effect within a sculptural situation, the curtain works are remarkable also for their moody evocation of unpopulated, empty spaces through the use of a very physical, body-oriented material, thus effecting a curious tension between corporeal presence and absence. They directly allude to the jarring cultural juxtaposition the artist experienced as a youth between the verdant and largely Caucasian neighborhoods in upstate New York where he grew up and the more intensely urban and African-American-dominated surroundings of his extended family. These works also suggest the beaded-curtain interior design items popular when Newkirk was a child. Rather than providing a structure that defines a space while remaining easily permeable, however, his curtains either hang impenetrably on the wall or, of late, are suspended from the ceiling to form a rectangular space into which the viewer is implicitly denied access. The scenes depicted in the more pictorially driven curtains rarely present a full view of a given landscape, but instead focus in a more fragmentary way on the tops of trees, telephone poles or houses – in essence, all of the typically overlooked phenomena that nonetheless remain immediately and affectingly familiar to anyone who has spent any time in the suburbs. Newkirk's willful exclusion of scenes that provide a more established sense of place, and his emphasis on images devoid of a human element, once again demonstrate how a somewhat melancholic tone of social estrangement and general disaffectedness with the world pervades almost every aspect of his oeuvre – a tone that becomes exaggerated by his works' seductive tactility and visual beauty.

It is perhaps completely unsurprising that Newkirk was prominently featured in the *Uncertain States of America* exhibition that opened at Astrup Fearnley Museum of Modern Art in Oslo in 2005 and has been making stops at various venues around the globe. One could easily describe the sensibility with which he works as an "uncertain state" and one that has much to do with his position as a black artist living and working in America at the dawn of the third millennium. Disenchanted, like many in the country, with a current administration that seems nothing if not cynical (a sentiment he directly expresses in his 2002 sculpture *Take What You Can*, featuring the words of the title executed in white neon), he joins many of his contemporaries in representing the world in a strikingly beautiful fashion laced with a sense of fatigued alienation. Echoing the sadly poignant refrains of both the Mahler song cited at the beginning of this text and the more recent cinematic moment of Jim Jarmusch and Taylor Mead, Newkirk comes to an uneasy peace with the world's shortcomings by delving further into the solace of his objects and images and encouraging us to do the same.

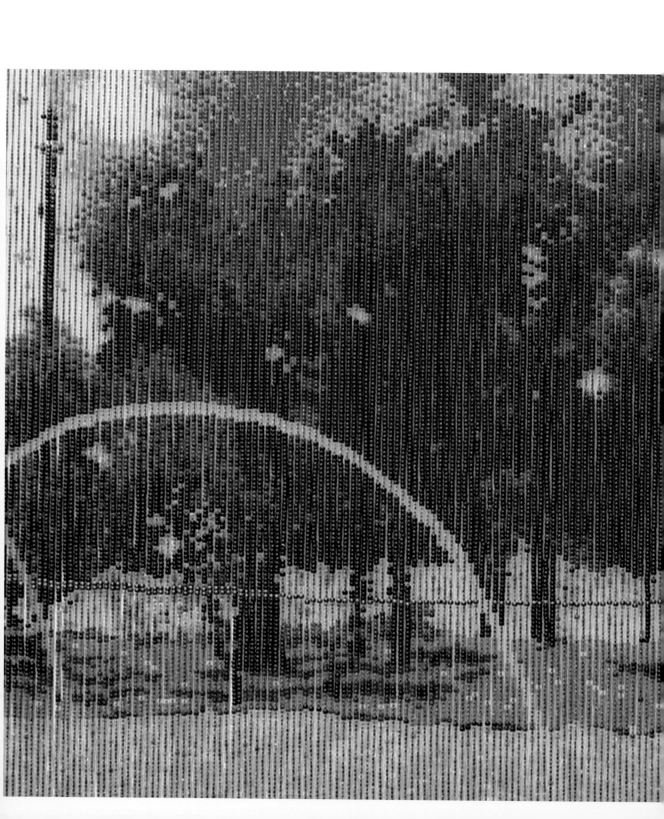

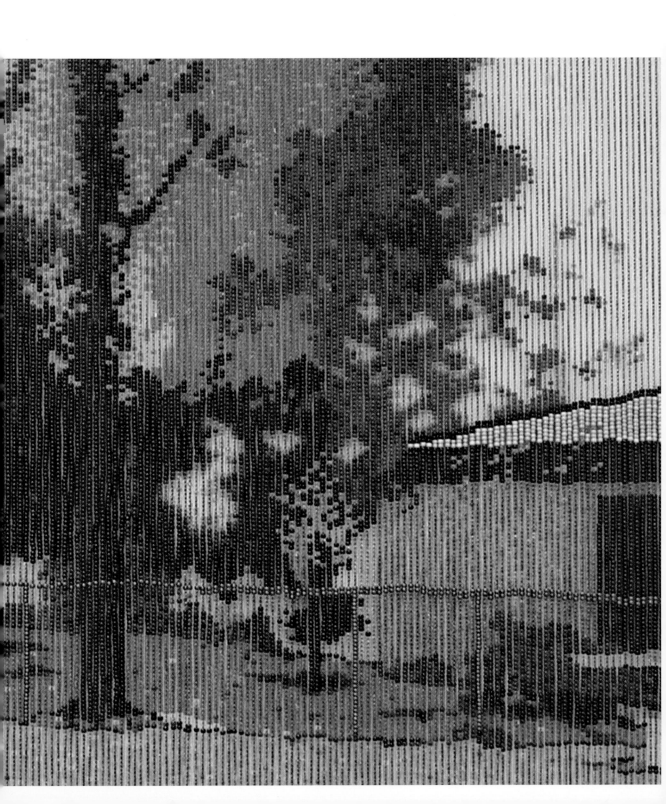

Jubilee, 1999
Plastic pony beads, micro braids, aluminum
96 x 96 in.
Collection of Dean Valentine

Cry Baby, 2001
Plastic pony beads, artificial hair
60 x 83 in.
Collection of Eileen Harris Norton, Santa Monica

Huff, 2001
Plastic pony beads, artificial hair, metal
96 x 48 in.
Collection of The Studio Museum in Harlem; purchase with
funds provided by the Acquisition Committee, 03.3.1

Suspect, 2001–02
Plastic pony beads, micro braids, plexiglass
48 x 48 in.
Collection of John H. Friedman

Bam Bam, 2003
Plastic pony beads, artificial hair, metal brackets
91 x 60 in.
Collection of the artist

Breaker, 2004
Plastic pony beads, artificial hair, hardware
72 x 72 in.
Collection of Ninah and Michael Lynne

Untitled (Modernist House), 2005
Plastic pony beads, artificial hair
45 x 45 in.
Collection of Marcia and Leonard Eitelberg

NASA, 2007
Plastic pony beads, micro braids, aluminum
93 x 48 in.
Collection of Bryan Lipinski, Dallas

Closely Guarded, 2000-01
Nickel-plated basketball hoops, artificial hair, plastic pony beads
120 x 48 x 24 in.
Collection of Lois Plehn

Assumption (PG), 2001
Color photocopies and acrylic on paper
43 x 29 in. framed
Courtesy the artist and The Project, New York

Assumption (F), 2001
Color photocopies and acrylic on paper
29 x 43 in. framed
Collection of David Alan Grier

Assumption (SG), 2001
Color photocopies and acrylic on paper
29 x 43 in. framed
Collection of David Alan Grier

Bumper, 2001
Two Inkjet photographs mounted on plexiglass and sintra
30 x 30 in. each
Collection of The Studio Museum in Harlem; purchase with
funds provided by the Acquisition Committee, 01.22.

Belvue Gardens, 2003
Neon, ed. of 10
24 x 22 in.
Courtesy the artist and The Project, New York

Groton, 2003
Acrylic, rubber, enamel
24 x 12 x 4 in.
Courtesy the artist and The Project, New York

Maybury, 2003
Neon, ed. of 5
33 x 24 x 24 in.
Courtesy the artist and The Project, New York

Tully, 2003
Wax and pigment
Dimensions variable
Courtesy the artist and The Project, New York

Untitled, 2004
Basketball hoops, braids, beads, enamel
24 x 19 x 175 in.
Courtesy Dennis Scholl

Take What You Can, 2002
Neon, ed. of 5 + 1 AP
48 x 60 in.
Courtesy the artist and The Project, New York

Void of Silence, 2001
C-print mounted on plexiglass
40 x 50 in.
Collection of Eileen Harris Norton, Santa Monica

EXHIBITION CHECKLIST

Haywood, 2002
Lambda print mounted on sintra with plexiglass front
48 x 64 in.
Courtesy the artist and The Project, New York

Flank, 2004
Color photograph mounted on sintra with plexiglass facing,
ed. of 3 + 2 APs
5 x 7 in.
Courtesy the artist and The Project, New York

Par, 2004
Color photograph mounted on sintra with plexiglass facing,
ed. of 3 + 2 APs
24 x 32 in.
Courtesy the artist and The Project, New York

1up, 2005
Color photograph mounted on sintra with plexiglass facing,
ed. of 3+1 AP
40 x 7 in.
Courtesy the artist and The Project, New York

2up, 2005
Color photograph mounted on sintra with plexiglass facing,
ed. of 3+1 AP
40 x 7 in.
Courtesy the artist and The Project, New York

3up, 2005
Color photograph mounted on sintra with plexiglass facing,
ed. of 3+1 AP
40 x 7 in.
Courtesy the artist and The Project, New York

Channel 9, 1999
C-print mounted on Plexiglas, framed
30 x 40 in.
Courtesy the artist and The Project, New York

Channel 11, 1999
Encaustic on wood panels, framed
64 x 49 in.
Collection of Barry Sloane, Los Angeles

Bixel, 2005
DVD Projection
TRT 05:00
Courtesy the artist and The Project, New York

Titan, 2007
DVD Projection
TRT 01:30
Courtesy the artist and The Project, New York

Modified Cadillac (Prototype #2), 1997
Pomade and pigment on wall
50 x 228 in.
The Museum of Contemporary Art, Los Angeles;
gift of Barry Sloane

Regina at 33, 2000
Pomade and pigment on wall
2 x 2 x 2 in.
Courtesy the artist and The Project, New York

ARTIST BIOGRAPHY

KORI NEWKIRK

Born 1970, Bronx, NY
Lives and works in Los Angeles, CA

Education

1997
Skowhegan School of Painting and Sculpture,
Skowhegan, ME

1997
MFA, University of California, Irvine, CA

1993
BF, The School of the Art Institute of Chicago, IL

Solo Exhibitions

2007–2008
Kori Newkirk: 1997–2007, The Studio Museum in Harlem,
New York, NY
Pasadena Museum of California Art, Pasadena, CA

2006
The Project, New York, NY
MC, Los Angeles, CA

2005
Museum of Contemporary Art, San Diego, CA
Art Gallery of Ontario, Toronto, Canada
Locust Projects, Miami, FL

2004
Museum of Contemporary Art, Cleveland, OH
Bodybuilder & Sportsman Gallery, Chicago, IL

2003
The Fabric Museum and Workshop, Philadelphia, PA
francesca kaufmann, Milan, Italy
The Project, Los Angeles, CA
The Project, New York, NY
To See It All, Henry Art Gallery, Seattle, WA

2002
Finesilver Gallery, San Antonio, TX
James Van Damme Gallery, Brussels, Belgium
Johnson County Community College, Overland Park, KS

2001
Rosamund Felsen Gallery, Santa Monica, CA
francesca kaufmann, Milan, Italy

2000
The Project, New York, NY

1999
Midnight Son, Rosamund Felsen Gallery, Santa Monica, CA
Legacy, Deep River, Los Angeles, CA

1998
Higher Standard, Project Room, Rosamund Felsen Gallery,
Santa Monica, CA

1997
BLOWOUT, Fine Arts Gallery, University of California, Irvine, CA

Group Exhibitions

2008
Tel Aviv Museum of Art, Tel Aviv, Israel

2007
Material for the Making, Elizabeth Dee Gallery, New York, NY
The Show on Vegas, M+B, Los Angeles, CA
Viewfinder, Henry Art Gallery, Seattle, WA
*Black Light/White Noise: Sound and Light in Contemporary
Art*, Contemporary Arts Museum, Houston, TX

2006
Alien Nation, Institute of Contemporary Arts, London, UK
The John Michael
Kohler Arts Center, Sheboygan, WI
*Black Alphabet: conTEXTS of contemporary African American
Art*, Zacheta National Gallery of Art, Warsaw, Poland
The Whitney Biennial 2006: Day for Night, Whitney Museum of

American Art, New York, NY
DAK'ART: 7th Dakar Biennial, Dakar, Senegal
Collection in Context: Gesture, The Studio Museum in
Harlem, New York, NY

2005
Uncertain States of America, Astrup Fearnley Museum of
Modern Art, Oslo, Norway; Center for Curatorial Studies at
Bard College, Annandale-on-Hudson, NY; Serpentine Gallery,
London, UK
Recent Acquisitions, Museum of Contemporary Art, Los
Angeles, CA
Southern Exposure, Museum of Contemporary Art,
San Diego, CA
Landscape Confection, Wexner Center of the Arts, The Ohio
State University, Columbus, OH; Contemporary Arts Museum
Houston, TX; Orange County Museum of Art, Newport Beach, CA

2004
Eye of the Needle, Roberts and Tilton Gallery, Los Angeles, CA
Summer Eye/Summarize, Jan Wiener Gallery, Kansas City, MO
California Biennial, Orange County Museum of Art, Newport
Beach, CA
Great White, Center for Curatorial Studies, Bard College,
Annandale-on-Hudson, NY
A.C., Elizabeth Dee Gallery, New York, NY
*African American Artists in Los Angeles, A Survey Exhibition:
Fade (1990-2003)*, Craft and Folk Museum and University Fine
Arts Gallery, California State University, Los Angeles, CA

2003
RE: Bank, Bank, Los Angeles, CA
Alumni Invitational, University Art Gallery, University of
California, Irvine, CA
Only Skin Deep, International Center of Photography (ICP), New
York, NY; Seattle Art Museum, Seattle, WA; San Diego Museum
of Art, San Diego, CA
Black Belt, The Studio Museum in Harlem, New York, NY; Santa
Monica Museum, Santa Monica, CA
DL: The 'Down Low' in Contemporary Art, Longwood Arts Project,
Bronx, NY
Hair Stories, Scottsdale Museum of Contemporary Art,
Scottsdale, AZ; The Contemporary Art Center, New Orleans,

LA; 40 Acres Art Gallery, Sacramento, CA; Crocker Art Museum, Sacramento, CA
Hot Summer in the City, Sean Kelly Gallery, New York, NY
A Century of Collecting: African-American Art, The Art Institute of Chicago, Chicago, IL

2002
Majestic Sprawl, Pasadena Museum of California Art, Pasadena, CA
Maximum Art, International Curatorial Space, New York, NY
Harlem Postcards, The Studio Museum in Harlem, New York, NY
Wallow, The Project, New York, NY
Storefront-LIVE!, Korean American Museum, Los Angeles, CA
Loop, Gallery 400, Chicago, IL
Beyond Stereotype, Dowd Fine Arts Gallery, SUNY Cortland, NY
Drive By, Reynolds Gallery, Richmond, VA
Short Stories – To See It All, Henry Art Gallery, Seattle, WA
Gene(sis): Contemporary Art Explores Human Genomics, Henry Art Gallery, Seattle, WA; Berkeley Art Museum, Berkeley, CA; Frederick Weisman Museum, Minneapolis, MN; The Mary And Leigh Block Museum of Art, Evanston, IL

2001
Boomerang: Collectors' Choice, Exit Art, New York, NY
One Planet Under a Groove: Hip Hop and Contemporary Art, Bronx Museum, Bronx, NY; Walker Art Center, Minneapolis, MN; Spelman College Museum of Fine Art, Atlanta, GA; Museum de la Stuck, Munich, Germany
Whippersnapper III, Vedanta Gallery, Chicago, IL
New Work: L.A. Painting, Hosfelt Gallery, San Francisco, CA
Snapshot, UCLA/Armand Hammer Museum, Los Angeles, CA; The Museum of Contemporary Art, Miami, FL
Freestyle, The Studio Museum in Harlem, New York, NY; Santa Monica Museum of Art, Santa Monica, CA; Capital Art, Track 16 Gallery, Santa Monica, CA
Painting 2001, Victoria Miro Gallery, London

2000
Fresh Cut Afros, Watts Towers Arts Center, Los Angeles, CA

1999
Southern California Car Culture, Irvine Fine Arts Center, Irvine, CA

Homeless in Los Angeles, The Mota Gallery, London, UK
After the Gold Rush, Thread Waxing Space, New York, NY

1998
I'm Still in Love with You, Women's 20th Century Club, Eagle Rock, CA
Same Difference, Guggenheim Gallery, Chapman University, Orange, CA
Disaster: Part of the "WhileUWait" series, Hollywood DMV, Los Angeles, CA
The Comestible Compost, Gallery 207 & Pavilion's, West Hollywood, CA

1997
PROP, Korean Cultural Center, Los Angeles, CA
Re:Bates, L.C. Bates Museum, Hinckley, ME
Black is a Verb!, WORKS/San Jose, San Jose, CA
Five Emerging Artists, Dan Bernier Gallery, Santa Monica, CA

1996
Just a Taste, Fine Arts Gallery, University of California, Irvine, CA
Finding Family Stories, Watts Tower Arts Center and Plaza de la Raza, Los Angeles, CA
Self Satisfy, Robert Berman Gallery, Santa Monica, CA

1995
Custom Complex, Helen Lindhurst Gallery, University of Southern California, Los Angeles, CA

Bibliography

2007
Cassel Oliver, Valerie. *Black Light/ White Noise: Sound and Light in Contemporary Art*. Houston: Contemporary Art Museum Houston, 2007.
Chasin, Noah. "Material for the Making." *Time Out New York*, February 1–7, 2007, 69.
Finkel, Jori. "A Reluctant Fraternity, Thinking Post-Black." *New York Times*, June 10, 2007, 29.
Molok, Nikolai. *2nd Moscow Biennale of Contemporary Art: Footnotes on Geopolitics, Market, and Amnesia*. Moscow:

Moscow Biennale Art Foundation, ArtChronika.

Schmerler, Sarah. "Post Tense." *Time Out*, August 23, 2007, 59.

Wilson, Michael. "Kori Newkirk." *Artforum*, September 2007, 158.

"Kori Newkirk: The Interpreter." *VIBE*, August 9, 2007, 156.

"Word of Mouth." *Conde Nast Traveler*, February 2007, 31.

2006

Armetta, Amoreen. "Kori Newkirk, The Project." *Flash Art*, May–June 2006, 124-125.

Chang, Richard. "A Challenging 'Landscape.'" *Orange County Register*, February 12, 2006.

Dea, Cynthia. "Crafty Approach to the Art World." *Los Angeles Times*, February 9, 2006, E50.

Esplund, Lance. "Canned Rebellion." *New York Sun*, March 2, 2006.

Field, Marcus. "How Do You Invade a Space This Big?" *The Independent on Sunday*, December 17, 2006.

Gebetsroither, Ines. "Moves, Cracks, Hair, David Hammons, Ellen Gallagher, Kori Newkirk." *Spike Art Quarterly*, Summer 2006, 60-68.

Glover, Michael. "An Orgy of Appropriation." *The Independent*, September 13, 2006, 20.

Gouveia, Georgette. "Touring the Whitney." *The Journal News*, April 9, 2006.

Holte, Ned. "The Other Left Bank." *Interview*, September 2006, 172-179.

Hubbard, Sue. "It's Life, But Not As We Know It." *The Independent*, November 30, 2006.

Kent, Sarah. "States of the Art." *Time Out*, September 20, 2006.

Knight, Christopher. "Adventurers Enticed by the Landscape." *Los Angeles Times*, February 28, 2006.

Schoenkopf, Rebecca. "Sugar Rush." *Orange County Weekly*, March 2, 2006.

Searle, Adrian. "Rebels without a Cause." *The Guardian*, September 12, 2006.

Sheets, Hilarie M. "Kori Newkirk." *ARTnews*, Summer 2006, 184.

Smith, Roberta. "Kori Newkirk." *New York Times*, March 17, 2006, E7.

Szupinska, Joanna. "Paint It Black." *Artillery*, December 2006, 46.

Teeman, Tim. "Close Encounters of the Nerd Kind." *The Times*, November 28, 2006.

Valdez, Sarah. "Kori Newkirk." *Paper*, February 27, 2006.

2005

Balzer, David. "Curtain Call." *Eye Weekly*, January 20, 2005.

Danto, Arthur C. "'Uncertain States of America' Astrup Fearnley Museum of Modern Art, Oslo, Norway." *Artforum*, December 2005, 274.

Goodard, Peter. "Beads Speak of Suburban Dreams and Delusions." *Toronto Star*, January 29, 2005.

Greenberg, Randi. "House for Contemporary Art." *Architectural Record*, September 2005.

Israel, Nico. "Candyland." *Vogue*, March 2005.

Jacques, Michelle. *Present Tense: Kori Newkirk*. Ontario: Art Gallery of Ontario, 2005.

Meyers, Terry R. "Kori Newkirk Museum of Contemporary Art San Diego." *Modern Painters*, April 2005.

Milroy, Sarah. "Subjugation and Illumination." *The Globe and Mail*, February 21, 2005, R1-2.

Newkirk, Kori. *African American Art*, 2005, 9.

Pincus, Robert L. "Go with the Current 'Glint' Uses Light to Guide Us To Vision." *San Diego Union Tribune*, February 10, 2005.

Teagle, Rachel. *Cerca Series: Kori Newkirk*. San Diego: Museum of Contemporary Art, San Diego, 2005.

Temple, Kevin. "Nervy Newkirk." *Now*, January 27-February 2, 2005, 67.

Strup Fearnley Museum of Modern Art. *Uncertain States of America*. Oslo: Strup Fearnley Museum of Modern Art, 2005.

2004

Ammirati, Domenick. "Black Belt." *ArtUS*, February-January 2004.

Chaich, John. "Sexuality Meets the Streets." *A & U*, February 2004.

Chang, Aimee. "Changing the Rules of the Game." *NYFA*, Spring 2004, 2-3.

Chattopadhyay, Colette. "Fading Into View." *Artweek*, March 2004, 12-13.

Cruchfield, Margo A. *Curve: Kori Newkirk*. Cleveland: Museum of Contemporary Art Cleveland, 2004.

Hall, Emily. "Doing the Do, Black Hair Is in the House." *The Stranger*, February 19-25, 2004.

Hawkins, Margaret. "Gender, Racial Issues Braided with a Touch of Humor in 'HairStories'." *Chicago Sun-Times*, May 14, 2004.

Herrmann, Andrew. "Axle Grease, Afros, Cornrows, Hot Combs, Dreadlocks." *Chicago Sun-Times*, April 30, 2004.

King, Rachel. "The Shock of the 'Do'." *Art News*, May 2004, 46.

Knight, Christopher. "A Chronicle of Race, Rage, Ritual." *Los Angeles Times*, February 17, 2004, E1-8.

Miles, Christopher. "Kori Newkirk." *Artforum*, January 2004, 160.

Nys Dambrot, Shana. "Reviews - National." *Art News*, May 2004, 156.

Pence, Elizabeth. "'RE:' at Bank." *Artweek*, March 2004, 19-20.

2003

Busser, Martin. "Pass the Mic to the Museum." *Konkret*, December 12, 2003.

Cotter, Holland. "DL: The Down Low in Contemporary Art." *New York Times*, October 2003, B33.

Golden, Thelma. "Like a Virgin." *Artforum*, December 2003, 126.

Kelley, Brendan Joel. "Hair Tactics." *New Times*, October 2, 2003.

Kim, Christine Y. "Color Blind." *V*, March-April 2003.

Kirsch, Elizabeth. "Black Vision." *Kansas City Star*, February 7, 2003.

Martin, Courtney J. "New York New York." *Flash Art*, July-September 2003, 67-68.

Murray, Derek Conrad. "Kori Newkirk at The Project." *Art in America*, November 2003, 160.

Sonna, Birgit. "Der Duft der Bronx." *Neue Zuricher Zeitung*, December 11, 2003.

Vanesian, Kathleen. "Day of the Dreads." *Phoenix News Times*, December 4, 2003.

International Center of Photography. *Only Skin Deep*. New York: International Center of Photography, 2003.

2002

Banai, Nut. "In the Groove." *Artnet.com*, February 28, 2002.

Caramanica, Jon. "Hip-Hop Don't Stop." *Village Voice*, January 9-15, 2002.

Honigman, Ana. "Freestyle: The Studio Museum: Harlem, New York." *Zing Magazine*, 2002.

Ilesanmi, Olukemi. "Kori Newkirk." *JCCC Publication*, May 2002.

Joo, Eungie. "Bring that Beat Back." *NYFA*, Spring 2002.

Kramer, Kathryn. "Kori Newkirk." *Dowd Gallery Catalogue*, February 8-March 8, 2002.

Murray, Dereck. "One Nation Under a Groove." *Nka Journal of Contemporary African Art*, Fall Winter 2002.

Smith, Roberta. "Hip Hop: One Planet Under a Groove." *New York Times*, January 18, 2002.

Spalding, David. "The Missing Link: Art, Biotechnology, and the Disappearance of Difference." *Artweek*, October 2002.

Thorson, Alice. "Drawing a Bead on Art." *Kansas City Star*, May 26, 2002, J1-8.

White, Susan. "Painting the Beaded Curtains of Allusion." *The Review*, July-August 2002, 70-71.

2001

Bowles, John. "Snapshot." *Artpapers*, November/December 2001, 73.

Cotter, Holland. "A Full Studio Museum Show Starts with 28 Young Artists and a Shoehorn." *New York Times*, May 11, 2001.

Chua, Lawrence. "Body Issues." *Jalouse*, May 2001, 66-69.

Dambrot, Shana Nys. "Snapshot." *Tema Celeste*, September/October 2001, 102.

Gioni, Massimiliano. "Freestyle." *Flash Art*, July-September 2001, 72.

Golden, Thelma et al. *Freestyle* New York: The Studio Museum in Harlem, 2001.

Kent, Sarah. "Paintings 2001." *Time Out London*, March 7-14, 2001, 63.

Knight, Christopher. "Cultural Evolution in Freestyle." *Los Angeles Times*, October 2, 2001, F1, F8.

Knight, Christopher. "Ideas are Being Bounced Around in These Basketball Puns." *Los Angeles Times*, June 22, 2001, F22.

Yee, Lydia, Franklin Sirmans and Greg Tate. *One Nation Under a Groove*. Bronx: Bronx Museum of Art, 2001.

Murray, Derek Conrad. "Freestyle." *Nka*, Fall/Winter 2001, 92-3.

Princenthal, Nancy. "Freestyle." *Artext*, August-October 2001, 92.

Saltz, Jerry. "Post-Black." *Village Voice*, May 16-22, 2001.

Subotnick, Ali. "Snapshot: New Art from Los Angeles." *Frieze*, October 2001, 99-100.

Takahashi, Corey. "One World, One Groove." *New York Newsday*, October 2001, B12-13.

Taylor, Tanis. "Metro Life." *London*, February 6, 2001, 18.

Tumlir, Jan. "Snapshot." *Artforum*, October 2001, 155.

Valdez, Sarah. "Freestyling." *Art in America*, September 2001, 134-139.

Viveros-Faune, Christian. "Freestyle." *New York Press*, June 2001.

Waxman, Lori. "Freestyle." *New Art Examiner*, November-December 2001, 90.

"The Vibe 100." *VIBE*, September 2001, 182.

"The New Masters." *VIBE*, May, 2001, 138-43.

"A 'Snapshot' of L.A. Artists." *Los Angeles Times*, June 6, 2001, F1, F4.
"Portrait of the Artist." *GQ*, April 2001, 214.

2000

Colpitt, Frances. "Kori Newkirk at Rosamund Felsen." *Art in America*, April 2000, 165.
Cotter, Holland. "Innovators Burst on Scene One (Ka-pow!) At a Time." *New York Times*, November 11, 2000.
Cotter, Holland. "A Gallery in Harlem Beats the Odds." *New York Times*, July 19, 2000, B1, B3.
Hainley, Bruce. "Kori Newkirk at Rosamund Felsen." *Artforum*, February 2000, 124.
Harvey, Doug. "Gender, Race." *LA Weekly*, August 4-10, 2000, 47.
"Galleries - Uptown, Art Domantay/Kori Newkirk." *The New Yorker*, November 13, 2000, 33-34.

1999

Harvey, Doug. "Closures, Openings." *LA Weekly*, November 26-December 2, 1999, 54.
Weidig, Alexis. "Los Angeles." *Sun Valley Art*, Summer 1999.
"Ed. Portfolio: Deep River." *Poliester*, Spring/Summer 1999, 54.

1998

Gaines, Malik. "Young, Gifted and Confused: 4 Emerging Artists Talk Politics." *XTra*, Fall 1998.
Miles, Christopher. "PROP." *Artweek*, February 1998, 23.
Schoenkopf, Rebecca. "Seething Toward Bethlehem." *O.C. Weekly*, March 27-April 2, 1998, 26.

1997

Berk, Amy. "Black is a Verb!" *Artweek*, December 1997, 19.
Kandel, Susan. "Young Ideas." *Los Angeles Times*, June 13, 1997.

1996

Muchnic, Suzanne. "Six Artists, Three Venues, One City." *Los Angeles Times*, October 27, 1996.
Simon, Leonard. "Finding Family Stories." October 1996.

CONTRIBUTORS' BIOGRAPHIES

HUEY COPELAND

Huey Copeland is an Assistant Professor of Art History at Northwestern University, focusing on modern and contemporary art with an emphasis on articulations of "blackness" in the visual field. At present, he is preparing a book manuscript that examines the aesthetic and political significance of slavery for the generation of post-Minimal African-American practitioners who emerged in the late 1980s.

DOMINIC MOLON

Dominic Molon is the Pamela Alper Associate Curator at the Museum of Contemporary Art (MCA) in Chicago, where he has organized exhibitions such as *Sympathy for the Devil: Art and Rock and Roll Since 1967* (2007), and curated major exhibitions the work of Wolfgang Tillmans (2006), Paul Pfeiffer (2003), Gillian Wearing (2002) and Sharon Lockhart (2001). He has also organized solo projects with Eija-Liisa Ahtila (1999), Steve McQueen (1996), Pipilotti Rist (1996) and Jack Pierson (1995), and is currently organizing exhibitions of Daria Martin and Liam Gillick. Molon has contributed to numerous publications, including *Art Review, Vitamin D: New Perspectives on Drawing, Art on Paper* and *Contemporary Magazine*, and has lectured and moderated panels internationally.

DEBORAH WILLIS

Deborah Willis is Chair of the Photography & Imaging Department at the Tisch School of the Arts at New York University and has an affiliated appointment with the Africana Studies Program at the College of Arts and Sciences. She was a 2005 Guggenheim Fellow and Fletcher Fellow, and a 2000 MacArthur Fellow, as well as the 1996 recipient of an Anonymous Was a Woman Award. She has pursued a diverse professional career as an art photographer, one of the nation's leading historians of African-American photography and a curator of African-American culture. Exhibitions of her work include *A Sense of Place* (2005) at the Frick Fine Arts Library at the University of Pittsburgh; *Regarding Beauty* (2003) at University of Wisconsin; *Embracing Eatonville* (2003-4) at Light Works in Syracuse, New York; and *HairStories* (2003-04) at the Scottsdale Contemporary Art Museum in Arizona. Her curated exhibitions include *Engulfed by Katrina: Photographs Before and After the Storm* (2006) for the Nathan Cummings Foundation in New York and *Imagining Families: Images and Voices and Reflections in Black* (1995) at the Smithsonian Institution in Washington, DC.

FOCA MEMBERSHIP LIST

Dewey E. Anderson
Judith and Alex Angerman
Michelle Angerman
Barbara and Charles Arledge
Leisa and David Austin

Shirley Martin Bacher
Beatrix and Gardy Barker
Pat Barkley
Ann and Olin Barrett
Michael and Judy Bauer
Geoffrey C. Beaumont
Toni and Steve Berlinger
Lanie Bernhard
Diane and Kendall Bishop
Suzanne and David Booth
Paul and Maxine Brooks
Linda Brownridge and Edward Mulvaney
Gay and Ernest Bryant
Bente and Gerald E. Buck
JoAnn and Ron Busuttil

Susan and John Caldwell
Maureen and Robert Carlson
Mary and Gus Chabre
Britt and Don Chadwick
Charlotte A. Chamberlain and Paul A. Wieselmann
Sara Muller and Dennis Chernoff
Mary Leigh Cherry and Tony de los Reyes
Kitty Chester
Ellie Blankfort and Peter Clothier
Pat and Ira Cohen
Barbara Cohn
Karen R. Constine
Francine and Herb Cooper
Diane and Michael Cornwell
Zoe and Don Cosgrove

Beryl Cowley
Louise Danelian
Kimberly Davis
Marina Forstmann Day and Paul J. Livadary
Hem-Young and Dominic de Fazio
Jon and Laurie Deer
Stephen P. Deitsch
Linda Dickason
Laura Donnelley

Lucille Epstein

Suzanne Felsen and Kevin Swanson
Joanne and Beau France
Merrill R. Francis
Judy and Kent Frewing
Lisa and Jerry Friedman

Marilyn Gantman
Richard and Eileen Garson
Eve Steele and Peter Gelles
Beverly and Bruce Gladstone
Sirje and Michael Gold
Dorothy Goldeen
Homeira and Arnold Goldstein
Donna Gottlieb
LouAnne Greenwald
Pat and Gene Hancock
Mary Elizabeth and Al Hausrath
Clinton H. Hodges
Niki Horwitch and Stephen Berg
Roberta Baily Huntley
Sally and Bill Hurt

Gloria and Sonny Kamm
Stephen A. Kanter
Tobe and Greg Karns

Nancy and Bernie Kaltler
Margery and Maurice Katz
Suzanne and Ric Kayne
Teri Kennady
Jeremy Kidd
Barbara and Victor Klein
Charlene and Sanford Kornblum
Hannah and Russel Kully

Daniel Lara and Carlyn Aguilar
Larry Layne and Sheelagh Boyd
Dawn Hoffman Lee and Harlan Lee
Ellen and David Lee
Gadi and Miri Leshem
Shirley and Philip Levine
Lydia and Chuck Levy
Peggy and Bernard Lewak
Bertram and Raquel Lewitt
Penny and Jay Lusche

Linda P. Maggard
Ann and Thomas Martin
David Mather and Pam Blacher
Barbara Maxwell
Laurie and Thomas McCarthy
Amanda and James McIntyre
Vicki and John Micha, MD
Carolyn and Charles D. Miller
Donna and Clint Mills
Cindy Miscikowski and Doug Ring
Joy and Jerry Monkarsh
Kay Mortenson and R. "Kelly" Kelly
Garna Muller
Ann and Bob Myers

Lois and Richard Neiter
Sandra Nichols
Mary Nord
Peter Norton

Sarah and Bill Odenkirk
Cathie and David Partridge
Leonard Pate
Jeanne Patterson
Gordanna and Stephen Perlof
Phil and Agnes Peters
R.L. and David A. Peters
Tom Peters
Bruce Picano and Joseph Morsman
Reese Polesky
Aimee Porter

Gina Russ Posalski and Irving Posalski
Dallas Price-Van Breda and Bob Van Breda

Dr. Stan and Lonette S. Rappoport
Joan B. Rehnborg
David Richards and Geoffrey Tuck
Ellie Riley
Lois Rosen
Richard and Karen Rosenberg

Barbara and Armin Sadoff
Judie Sampson and Richard Crane
Helene and Robert Schacter
Kathleen Schaefer
Marcia and Dick Schulman
Joanna and Ryan Scott
Jennifer and Anton Segerstrom
Marjorie and David Sievers
Gary and Gilena Simons
Carole Slavin
Pam Smith
Kris Sommer and Richard Stevenson
Penny and Ted Sonnenschein
Laurie Smits Staude

Betina Tasende
Laney and Thomas Techentin
Jocelyn Tetel
Sue Tsao
Elinor and Rubin Turner

Donna Vaccarino
Carolyn and Bob Volk

Fern and Leon Wallace
Julie and Scott Ward
Sheila and Bill Wasserman
Ailene and O.J. Watson
Kathy Watt
Bob Weekley
Gloria Werner
Linda and Tod White
Mili Julia Wild
Jene M. Witte
Lynn and Larry Wolf
Laura-Lee and Robert Woods

Sandee Young

Exhibitions initiated and sponsored by the Fellows of Contemporary Art

FOCA EXHIBITIONS LIST

The concept of the Fellows of Contemporary Art (FOCA), as developed by its founding members in 1975, is unique. Membership dues are used to initiate and sponsor exhibitions for emerging and mid-career California artists, publish outstanding professional catalogues and other documents, encourage a broad range of exhibition sites and provide stimulating educational experiences for the members. The intent is to collaborate with the art community at large and nurture the expression of creative freedom.

2007
Kori Newkirk: 1997–2007
Thelma Golden, Curator
The Studio Museum in Harlem
November 14, 2007-March 9, 2008

2006
FOCAFellowships: Vincent Fecteau, Evan Holloway Monica Majoli
Armory Center for the Arts, Pasadena
September 24 – December 2, 2006

2005
Thing
James Elaine,
Aimee Chang
and
Christopher Miles, Curators
Hammer Museum, Los Angeles
February 6 – June 5, 2005

2004
Topographies
Karen Moss, Curator
San Francisco Art Institute
March 19 – May 8, 2004

2003
George Stone: Probabilities – A Midcareer Survey
Noel Korten, Curator
Barnsdall Municipal Art Gallery, Los Angeles
September 9 – November 16, 2003

2003
Whiteness, A Wayward Construction
Tyler Stallings, Curator
Laguna Art Museum, Laguna Beach
March 16 – July 6, 2003

2002
On Wanting to Grow Horns: The Little Theater of Tom Knechtel
Anne Ayers, Curator
Ben Maltz Gallery, Otis College of Art and Design, Los Angeles
November 9, 2002 – February 15, 2003

2002
Michael Brewster: See Hear Now – A Sonic Drawing and Five Acoustic Sculptures
Irene Tsatsos, Curator
Los Angeles Contemporary Exhibitions
February 16 – April 20, 2002

2000
Flight Patterns
Connie Butler, Curator
The Geffen Contemporary at Museum of Contemporary Art, Los Angeles
November 12, 2000 – February 11, 2001

1999
Bruce and Norman Yonemoto: Memory, Matter, and Modern Romance
Karin Higa, Curator
Japanese American National Museum, Los Angeles
January 23 – July 4, 1999

1999

Eleanor Antin
Howard N. Fox, Curator
Los Angeles County Museum of Art
May 23 - August 23, 1999

1998

Access All Areas
Japanese American Cultural & Community Center,
Los Angeles
June 6 - July 26, 1998

1997

Scene of the Crime
Ralph Rugoff, Curator
UCLA at the Armand Hammer Museum of Art and Cultural
Center, Los Angeles
July 22 - October 5, 1997

1995

Llyn Foulkes: Between a Rock and a Hard Place
Marilu Knode, Curator
Laguna Art Museum, Laguna Beach
October 27, 1995-January 21, 1996

1994

Plane/Structure
David Pagel, Curator
Otis Gallery, Otis College of Art and Design, Los Angeles
September 10 - November 5, 1994

1993

Kim Abeles: Encyclopedia Persona,
A Fifteen-Year Survey
Karen Moss, Curator
Santa Monica Museum of Art
September 23 - December 6, 1993

1992

Proof: Los Angeles Art and the Photograph, 1960–1980
Charles Desmarais, Curator
Laguna Art Museum, Laguna Beach
October 31, 1992-January 17, 1993

1991

Facing the Finish: Some Recent California Art
Robert Riley
and
John Caldwell, Curators
San Francisco Museum of Modern Art
September 20 - December 1, 1991

1991

Roland Reiss: A Seventeen-Year Survey
Betty Ann Brown, Curator
Los Angeles Municipal Art Gallery
November 19, 1991 - January 19, 1992

1990

Lita Albuquerque: Reflections
Henry Hopkins, Curator
Santa Monica Museum of Art
January 19 - April 1, 1990

1989

The Pasadena Armory Show 1989
Noel Korten, Curator
Armory Center for the Arts, Pasadena
November 2, 1989 - January 31, 1990

1988

Jud Fine
Ronald Onorato, Curator
La Jolla Museum of Contemporary Art
August 19 - October 2, 1988

1987

Variations III: Emerging Artists in Southern California
Melinda Wortz, Curator
Los Angeles Contemporary Exhibitions
April 22 - May 31, 1987

1987

Perpetual Motion
Betty Turnbull, Curator
Santa Barbara Museum of Art
November 17, 1987 - January 24, 1988

FOCA
EXHIBITIONS
LIST
CONTINUED

1986

William Brice
Ann Goldstein, Curator
Museum of Contemporary Art, Los Angeles
September 1 - October 19, 1986

1985

Sunshine and Shadow: Recent Painting in Southern California
Susan Larsen, Curator
Fisher Gallery, University of Southern California,
Los Angeles
January 15 - February 23, 1985

1985

James Turrell
Julia Brown, Curator
Museum of Contemporary Art, Los Angeles
November 13, 1985 - February 9, 1986

1984

Martha Alf Retrospective
Josine Ianco-Starrels, Curator
Los Angeles Municipal Art Gallery
March 6 - April 1, 1984

1983

Variations II: Seven Los Angeles Painters
Constance Mallinson, Curator
Gallery at the Plaza, Security Pacific National Bank, Los Angeles
May 8 - June 30, 1983

1982

Changing Trends: Content and Style – Twelve Southern
California Painters
Robert Smith, Curator
Laguna Beach Museum of Art
November 18, 1982 - January 3, 1983

1981

Craig Kauffman Comprehensive Survey 1957–1980
Robert McDonald, Curator
La Jolla Museum of Contemporary Art
March 14 - May 3, 1981

1981

Paul Wonner: Abstract Realist
George Neubert, Curator
San Francisco Museum of Modern Art
October 1 - November 22, 1981

1980

Variations: Five Los Angeles Painters
Bruce Hiles
and
Donald Brewer, Curators
University Art Galleries, University of Southern California,
Los Angeles
October 20 - November 23, 1980

1979

Vija Celmins: A Survey Exhibition
Betty Turnbull, Curator
Newport Harbor Art Museum, Newport Beach
December 15, 1979 - February 3, 1980

1978

Wallace Berman Retrospective
Hal Glicksman, Curator
Otis Gallery, Otis College of Art and Design,
Los Angeles
October 24 - November 25, 1978

1977

Unstretched Surfaces/Surfaces Libres
Jean-Luc Bordeaux,
Jean-Francois de Canchy
and
Alfred Pacquement, Curators
Los Angeles Institute of Contemporary Art
November 5 - December 16, 1977

1976

Ed Moses Drawings 1958–1976
Joseph Masheck, Curator
Frederick S. Wight Art Gallery, University of California,
Los Angeles
July 13 - August 15, 1976

THE STUDIO MUSEUM IN HARLEM

BOARD OF TRUSTEES

Raymond J. McGuire, Chairman
Carol Sutton Lewis, Vice Chairperson
Reginald Van Lee, Treasurer
Anne B. Ehrenkranz, Secretary

Gayle Perkins Atkins
Jacqueline L. Bradley
Kathryn C. Chenault
Gordon J. Davis
Reginald E. Davis
Susan Fales-Hill
Dr. Henry Louis Gates Jr.
Sandra Grymes
Joyce K. Haupt
Arthur J. Humphrey Jr.
George L. Knox
Nancy L. Lane
Dr. Michael L. Lomax
Tracy Maitland
Rodney M. Miller
Eileen Harris Norton
Dr. Amelia Ogunlesi
Corine Pettey
David A. Ross
Charles A. Shorter Jr.
Ann Tenenbaum
John T. Thompson
Michael Winston

Hon. Kate D. Levin, Ex-Offico, Commissioner of Cultural Affairs,
City of New York

Karen A. Phillips, Ex-Officio, Representative for Hon. Michael
Bloomberg, Mayor, City of New York

THE
STUDIO
MUSEUM
IN
HARLEM
STAFF

Niger Akoni, Security Officer
Shannon Ali, Visitor and Security Services Manager
Anaya Armstead, Security Officer
Ayhan Aydinalp, Museum Store Sales Associate
Timotheus Ballard, Acting Building Supervisor
Marc Bernier, Head Preparator
Naomi Beckwith, Associate Curator
Kalia Brooks, Public Programs Coordinator
Robert K. Brown, Membership Associate/Associate
 Database Administrator
Kenneth Bryant, Security Officer
Romi Crawford, Curator and Director of Museum Education
 and Public Programs
Carmelo Cruz, Finance Manager
Leevancleef Duplessis, Custodian
Ali Evans, Public Relations Manager and Editor
Jamie Glover, Museum Store Manager
Thelma Golden, Director and Chief Curator
Nola Grant, Security Supervisor
Lea K. Green, Director of Special Projects
Elizabeth Gwinn, Executive Assistant to the Director
Lauren Haynes, Curatorial Assistant
Tiffany Hu, Public Relations Coordinator
Leslie Hewitt, Artist-in-Residence 2007-08
Fitzroy James, Security Officer
Paul James, Security Officer
Dennell Jones, Human Resources/Executive Assistant
Christine Y. Kim, Associate Curator
Carol Martin, Education and Public Programs Assistant
Rebecca Matalon, Education and Public Programs Assistant
Sheila McDaniel, Deputy Director, Administration and Finance
Jonathan McLean, Custodian
Nisette Oyola, Museum Store Sales Associate
Terry Parker, Security Supervisor
Jane Penn, Associate Development Director, Institutional
Giving
Reynold RiBoul, Security Officer
Lisa Ann Richardson, Security Officer
Tanea Richardson, Artist-in-Residence 2007-08
Norris Robinson, Security Officer
Josefina Rojas, Security Officer
Khalid Sabree, Fire Safety Director
Deirdre Scott, Director of Technology

Shanta Scott, School and Family Programs Coordinator
Leonard Smalls, Security and Deputy Fire Safety Officer
Jovan C. Speller, Development Assistant
Vivienne Valentine, Manager, Grants and Corporate Relations
Ronisha Washington, Security Officer
Russell Watson, Expanding the Walls/Youth Programs
 Coordinator
Teddy Webb, Security Officer
Michael Williams, Security Officer
Ayeshah Wiltshire, Manager of Museum Education and
 Public Programs
J. Saya Woolfalk, Artist-in-Residence 2007-08
Susan Wright, Special Events Manager
Trisha Young, Security Officer